DATE			

PORTRAIT PAINTING IN WATERCOLOR

PORTRAIT PAINTING IN WATERCOLOR

Charles Reid

WATSON-GUPTILL PUBLICATIONS/NEW YORK

This book is for Judy and Peggy
and for my father,
who wanted me to be an artist.

First published 1973 in the United States and Canada by Watson-Guptill Publications,
a division of Billboard Publications, Inc.
1515 Broadway, New York, N.Y. 10036

Library of Congress Cataloging in Publication Data
Reid, Charles, 1937-
 Portrait painting in watercolor.
 Bibliography: p.
 1. Portraits. 2. Water-color painting—
Technique. I. Title.
ND2200.R44 751.4′22 72-13569
ISBN 0-8230-4192-1

Distributed in the United Kingdom by Phaidon Press Ltd.,
Musterlin House, Jordan Hill Road, Oxford OX2 8DP

Manufactured in Japan

First Printing, 1973
2 3 4 5 6/93 92

Acknowledgments

If this book is good, it's due to the efforts of my editor Lois Miller and the designers of the book, James Craig and Robert Fillie.

I'd also like to thank Don Holden for his continued help and encouragement.

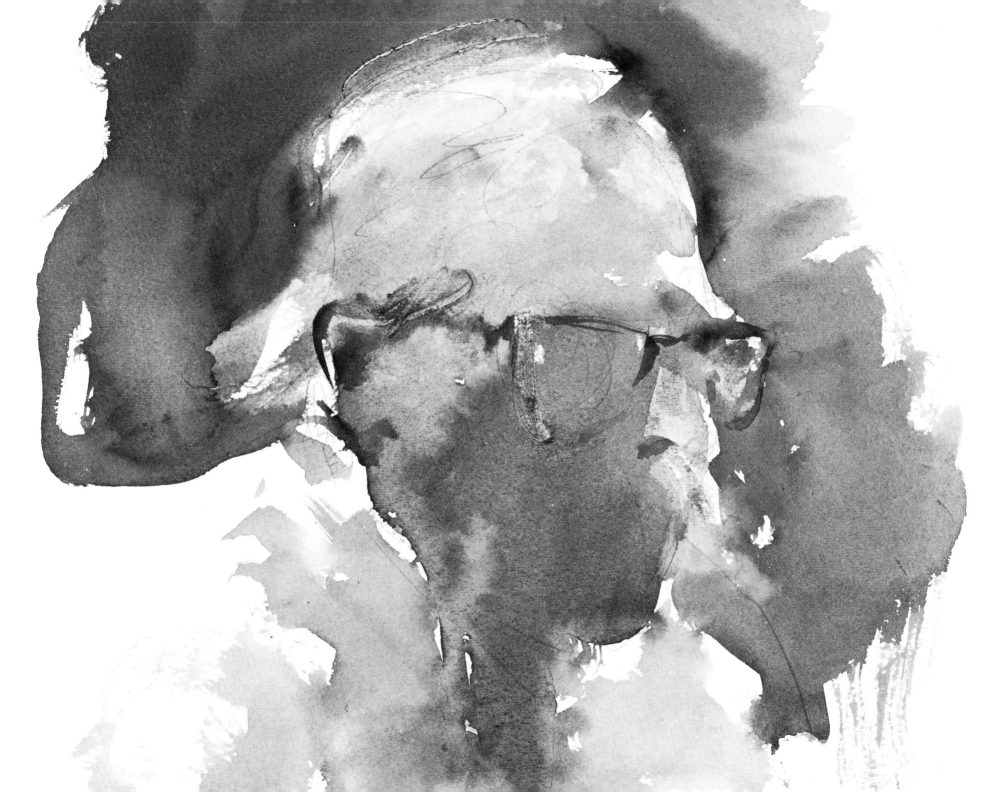

Contents

Quick Sketch. 12″x12″, Fabriano paper. This is a very quick sketch, and I made no attempt whatsoever to develop any detail. I relied on light sections in the hair, nose and forehead to carry the picture. I left the white shirt untouched in certain sections and allowed the shadow areas and the areas of similar value to blend together. This type of sketch is very good exercise and fun to do, and I finished it in about three minutes. I never worry whether something like this will come off or not. I do it and put it aside and start again. Later, if it looks good, I keep it. If it's a failure I just turn it over and work on the other side. Occasionally, I think it's good for any artist to work this way. It helps you avoid treasuring your work and feeling that it's too precious. And I think it's good to avoid judging a picture right away. Do a painting and put it aside. Your eye will be much fresher later.

PORTRAIT PAINTING IN WATERCOLOR

Introduction

For me, watercolor is a spontaneous and suggestive medium, and I find using it an exciting adventure.

I've heard several "myths" about painting with watercolor, and I disagree with them all. For example, I've heard it said that you can't make any corrections or changes with this medium—that you have to be "right" the first time. This just isn't true! I've found that my corrections and changes often "make" a painting, and I hope you'll see for yourself what I mean as you follow the demonstrations in this book.

Another misconception about this medium is that it's much harder to paint people than to paint other subjects with watercolor. Again, I disagree! Watercolor is ideal for spontaneous, informal portraits, and it's certainly possible to paint highly "finished" portraits with watercolor. I'd rather go to oil or acrylic for my "formal" portraits, but this is a very personal preference. I simply find it helpful and interesting to switch back and forth between watercolor and oil.

I can't stress enough the importance of knowing how to *draw* before you learn how to *paint* portraits. Drawing is beyond the scope of this book, but in the Bibliography I've listed several fine books on drawing heads, hands, and figures, which you might want to study if you have doubts about your drawing.

For the demonstrations in this book, I've painted each step on a separate sheet of paper—to make the "lessons" as clear as possible—so you'll probably find minor variations as you progress from one illustration to the next. I think these slight differences from one step to another should actually be helpful to you. They'll show you that watercolor is anything but an exact science, and that each painting is a new experience! I plan my compositions carefully, and I begin with accurate drawings, but I don't use any exact system once I start to paint. I like things to just happen.

For me, this approach creates the excitement and adventure that are so much a part of painting with watercolor. In the following demonstrations, I hope you'll share this sense of adventure with me.

Sketch Class, 8″x14‴, Fabriano paper. This is just a very quick note of one of the men who was working in our sketch group. There are mistakes and poorly done areas, but I think a painting such as this is valuable in developing an ability to put down what you see directly and spontaneously. Even if the painting doesn't come off as a whole, there might be one or two sections that do work.

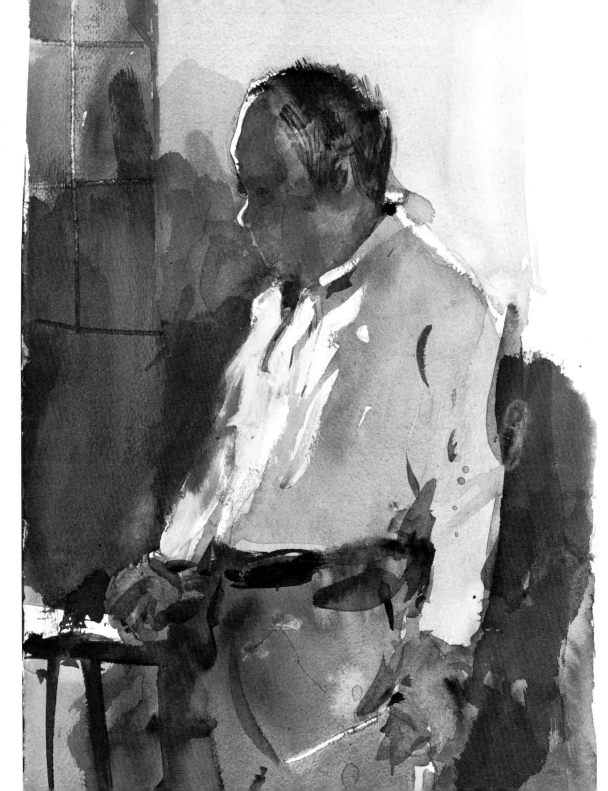

Materials

About the only unpleasant aspect of painting with watercolor is going out to the art store to buy the necessary materials. Good watercolor brushes, paper, and colors are very expensive. The only thing I can say about this is that good materials are an excellent investment. Try to steel yourself against the expense, knowing that you just can't do your best work if you use poor materials.

Brushes

There are two main types of brushes, oxhair and sable.

Oxhair brushes don't form the fine point that's necessary to do the important detail work in painting a head, for example. On the other hand, an oxhair brush would be fine for the early demonstrations in this book, while you're just becoming familiar with the general techniques of watercolor painting.

Sable brushes are the best, but they come in varying qualities. You should buy as good a brush as you can possibly afford. The three sable brushes I suggest are a 1″ flat, a Number 10 round, and a small, Number 3 or Number 4 round. The numbering of brushes seems to differ from one manufacturer to another. For example, the Winsor & Newton Number 8 is approximately the same size as the Grumbacher Number 10; the smaller sizes differ correspondingly. Investigate the differences yourself, and choose the brushes you feel most comfortable with.

It's very difficult to do a good painting with a brush that's become tired and soggy, so you should always try to use one that comes to a good point. Save your old brushes for background areas and use your good brushes for precision work.

Paper

I think good watercolor paper is very important. By "good," I mean a paper that's fairly soft and absorbent. Cheaper papers tend to be hard, often repel the paint, and sometimes seem to have an oily film that doesn't really take the color well. But again, you can certainly use a cheaper paper until you have a good idea of how watercolor works.

When you use expensive paper, you may find that you're afraid of it—that you don't want to ruin it—and this may make for very tentative and timid efforts. Try to accept the fact that you *are* going to ruin some very good paper and that it's just part of learning to paint! Whenever you can, work on both sides of a sheet of watercolor paper (apparently there is a right and a wrong side, but I've never found out which is which).

Watercolor paper comes in various weights and textures. The textures run from very smooth, called hot-pressed, to rougher textures, called cold-pressed (moderately irregular) and rough (which means *really* rough). I'd suggest that you use a fairly smooth texture like hot-pressed, although later on you should experiment with both rough and smooth paper and see which you really like best.

Hot-pressed, cold-pressed, and rough papers come in weights running from the very light 72 lb. to the medium weight 140 lb. to the very heavy 300 lb. The weight of a particular paper means the number of pounds that a ream (500 sheets) of that paper weighs. The paper is normally the standard Imperial size—22″ x 30″. The 72 lb. paper is really too thin and light for watercolor work, unless you don't plan to make any mistakes. The heavier paper, such as 140 lb. or—even better—300 lb. takes

more punishment. The 300 lb. paper is especially good to use. You'll find you can make all the corrections you want on it without fear of its buckling—becoming wavy.

Paintbox and Palette

Since you'll probably do most of your watercolor work indoors, it doesn't really matter what you carry your paints and brushes in. However, a fisherman's tackle box or a carpenter's tool box makes a very handy container for all of your equipment. Both types of boxes have small compartments that are excellent for holding paint tubes and brushes, and the large compartment beneath is a good place for your palette and water container. I'd suggest that you buy a plastic tool box because it won't rust. You'll probably find a good one at your local discount house.

I use an enamel butcher's tray when I work in my studio and a folding metal palette when I work away from my studio. The butcher's tray makes an excellent studio palette. It has a large area for mixing washes, and it lasts forever. If you buy a folding palette, be sure it has a large enough mixing area and plenty of room for your colors around the edge. *Don't* buy a palette that has ready made cakes of dry color on it—buy one that's meant for tube colors. And don't buy a plastic one. They don't last and it's difficult to mix pigment and water on them.

Easels

I've never used an easel for my watercolor painting, because I find them more trouble than they're worth. An easel is just one more thing to carry and,

when I'm carting around a drawing board, paper, and a paintbox, I already have plenty to carry. In my studio, I use two folding chairs as my easel. I sit on one, set the other opposite me, prop my drawing board against the back of it, and use the seat to hold my palette, brushes and water jar. When I work outside, I usually prop my board against a handy rock or simply set it on the ground and kneel in front of it.

Some artists prefer to sit in a chair and place their paper and board on the floor in front of them. The advantage of painting in this position—so far from the paper—is that you can't really "tighten up" on your work; you've got to swing your arm and you tend to be much freer with your painting.

If you're working in a studio, I'd suggest that you use an adjustable drawing table—one that you can fix in a horizontal position when you want to paint standing up and adjust all the way to vertical when you want to sit and paint.

Try to find the place and the painting position most comfortable for you. As you become more involved with watercolor painting, you'll certainly develop your own method of placing your drawing board and paper.

Colors

I'll go into a complete discussion of color in the chapters on Selecting Color and Mixing Color. For the black and white projects in this book, you should buy either ivory black or Payne's gray. When you buy these—and all of your colors—I suggest that you buy *tube* paints, rather than dry cakes of color. Perhaps this also falls into the realm of personal preference—it may be quite possible to do excellent paintings with cake colors—

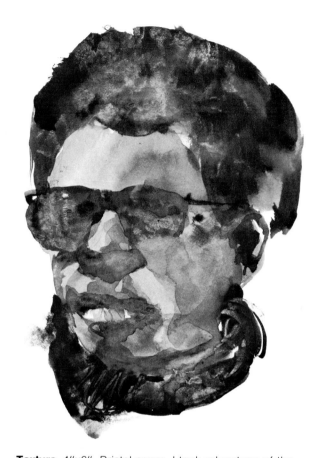

Texture. 4"x6", Bristol paper. I took advantage of the hard surface of the Bristol paper to create some special effects here. For example, notice the very high-keyed cast shadow under the nose. This was originally much darker, but I dropped some water into the shadow and, as the area dried, the water left a rather etched effect. Instead of describing the nose with the usual dark value, I indicated its presence by leaving the hard boundaries around the cast shadow. While the hair was still wet, I blotted it with a tissue to create texture. I suggested the sweater and, as the area dried, I scratched out some texture with my fingernail. I also used my finger to blot the mouth and create a very effective texture.

but I think you'll find it much easier to put the right amount of color on your palette when you use soft tube color. And be sure that you buy *transparent* watercolor paints, not gouache. Gouache is opaque watercolor, and it can't be used for transparent watercolor painting.

Miscellaneous

Your drawing board should be fairly steady and should provide a good, solid surface to paint on. As I mentioned earlier, I often work with my board in a vertical position, although I've heard that this is considered very unusual. Wet washes run when the board is vertical, and I think you'll see many of these "runs" in the illustrations in this book. I don't find "running" bothersome, but perhaps you will, and it might be better for you to work with your board in a horizontal or diagonal position.

When I go to a sketch class or work in my house, I carry a fairly small drawing board—either a standard, commercial pine drawing board or a piece of Masonite or plywood—about 16" x 20". Pushpins don't penetrate Masonite, but you can carry a role of masking tape to attach your paper to the board.

I always have a kneaded eraser, pencils, and a razor blade in my box. An eraser should be used very carefully. Never use a hard, office type eraser and, even when you use a soft eraser such as a kneaded, be careful not to overdo your corrections. If you scrape the surface of the paper, it will become rough, it won't hold the paint as well as it should, and the rough texture of the erased area will show through your paint.

Use a 2B office pencil. It's fairly soft, but not too soft. Hard pencils tend to dig up the paper and, al-

though they make very nice light lines, I think you'll find yourself bearing down as you try to develop your drawings. Very soft pencils, such as 4B or 6B, tend to leave very dark lines that become bothersome at the painting stage.

Razor blades are very useful for scratching out light areas when a painting is dry. You can also use razor blades to scratch out when your painting is wet, but be careful not to dig up the paper. It's also possible to overuse razor blades and ruin a painting. Just a *few* highlights are necessary in any painting, and too much scratching out will create a very unpleasant, "too busy" effect.

I also use the tip of my brush handle and my fingernail to scratch out light lines while washes are still wet. I think you'll notice that I've used both these methods to scratch out strands of hair in some of the demonstrations.

For water containers, I use plastic jars—the kind that margarine comes in. They fit nicely into my paintbox and they don't break. An Army canteen and a matching cup also make a very good water carrier and container.

I use pushpins to attach my paper to my drawing board—unless I'm using a Masonite board. In that case, I keep a roll of 1" masking tape handy to fasten my paper to the board.

Finally, I always carry a box of facial tissues. They're extremely helpful in many ways. They're excellent for blotting brushes and for blotting areas of paintings that are too wet and are getting out of control. I also use them to scrub out mistakes and to soften edges that have become too hard. I think facial tissues are a necessity in any watercolor kit, but you may find that paper towels work just as well.

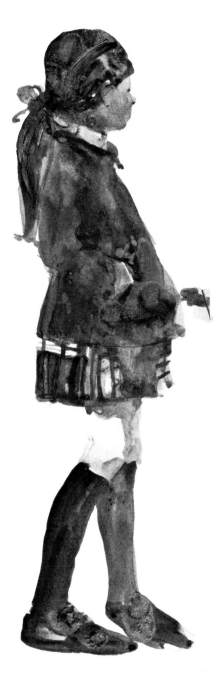

The Head

Standing Girl. 4"x8", Bristol paper. As you can see here, it's possible to paint a portrait without really showing the face. You can simply capture the subject's particular attitude. I'm sure you've seen someone walking down the street and known who that person was before you could really see any features. Attitude is a very important part of a portrait, and you should try to capture this as well as the specific features.

1
Head in Three-Quarter Lighting

In the five demonstrations that follow, you'll be using just two values—one light and one darker—to represent lights and shadows on a highly simplified head form. Naturally, you won't always have such simple value problems: many of the heads you paint will be in fairly complicated and diffused lighting situations. Even in these simple exercises, however, remember that the head is a *solid*, egg-shaped form, and be sure that all of your shadows indicate this.

Later on, in the sixth demonstration, we'll introduce a third value, or halftone. But, in the beginning, remember that simple shadow shapes can be your best friends and, whenever possible, pose your model under a single, fairly definite light source. A single light source will develop the simple shadow shapes I'll be talking about.

In this demonstration, we'll assume that the light is coming from the left, so the shadow will be on the right side of the face. For our purposes, the "right" side of the face will always mean *your* right, and "left" will always mean *your* left. As you sketch outlines in pencil, remember that the pencil lines are just a general guide. Get used to working broadly and freely with your brushstrokes, and don't try to fill in the outline carefully.

As you prepare your washes, squeeze a generous supply of black paint onto your palette. Don't be stingy—give yourself enough paint to do many practice heads. If the paint dries between sessions, you can dampen it with water to make it workable again. To make your pigment lighter, dip your brush into the water supply and shake it to get rid of the excess water. Then dip the brush into the edge of the pile of pigment on your palette and draw some of the paint out onto the working area of the palette. Work the dampened brush and the pigment together to make a "puddle." If this puddle is still too dark, dip your brush back into the water supply, shake it, and work it into the puddle again.

For this exercise, you'll need a good sable watercolor brush that "points" well; a Number 8 or Number 9 will be fine. You'll also need a palette, a water jar, a tube of ivory black, an HB, 2A, or 2B pencil, a drawing board, and pushpins. For paper, use a good quality hot-pressed watercolor paper with not too much texture. The size of the paper isn't very important. You can cut a full sheet into eight pieces, and you can use both sides if it's fairly heavy—at least 140 lbs. Remember to wait until the first attempt is dry before you work on the other side.

When you're ready to begin Step 1, pin your paper to your board, place a pushpin in each corner, and set your palette and water supply in a convenient place. You can work standing, with the board held horizontally, or you can sit, with your board held at an angle.

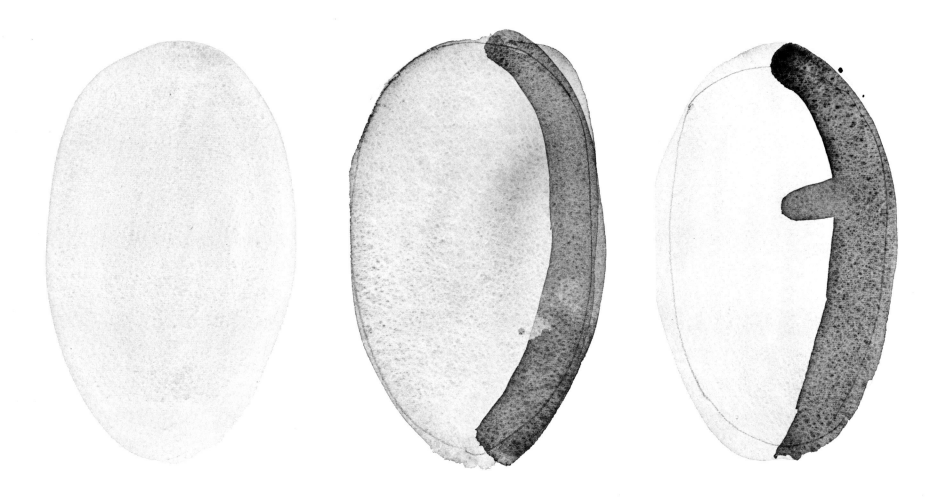

Three-quarter Lighting: Step 1. With your pencil, sketch in a simple oval, about 4" or 5" high. Don't labor over it. Next, sqeeze some black paint onto your palette, and, as I've already described, make a fairly light wash that's still noticeably darker than the white paper. Then, with a loaded brush, make broad strokes within the oval. Don't worry if some strokes go outside the pencil outline.

Three-quarter Lighting: Step 2. Allow the first wash to dry. Then dip your brush in the water jar, give it a shake, and go back to your pile of black pigment. This time, make a much darker puddle than the value you used in Step 1, but use enough water to keep it from being pure black. With one or two good, definite strokes, paint a strip about 1" wide down the entire right (your right) side of the face.

Three-quarter Lighting: Step 3. Now for a very simple indication of the eye on the shadow side of the face. The shadow strip you made in Step 2 should still be wet. Load the brush with the same dark value and, starting about a third of the way down the dark strip, make a horizontal jog out into the "face," stopping when you're almost to the middle. You have now indicated the shadow under the eyebrow.

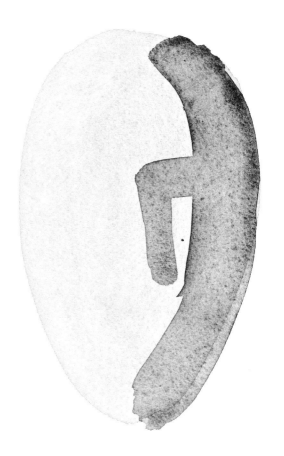

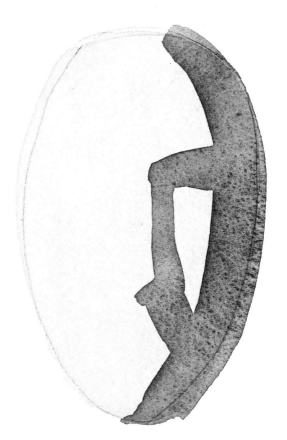

Three-quarter Lighting: Step 4. Next is the shadow side of the nose. You probably have enough paint on your brush, so reloading shouldn't be necessary. Starting where you left off with the eye indication, make a downward stroke that slants slightly toward the right. The nose becomes broader toward the tip, and the shadow should widen here to reflect this. All noses differ, but let's make this one about one-third the length of the face.

Three-quarter Lighting: Step 5. Reload your brush with the same value. Give it a shake to remove excess paint before you go back to the paper. From the end of your last stroke, make a very short jog downward and to the left. This indicates the bottom plane of the nose. Now make a diagonal, downward stroke to the right, to connect the bottom plane with the main shadow stroke you made in Step 2.

Three-quarter Lighting: Step 6. The mouth is just short of halfway between the nose and the chin, closer to the nose. Starting where the connecting stroke you just made meets the main shadow, make a horizontal stroke to the left. The length of this stroke depends on how wide you want to make the mouth. At the end of the stroke, press down on your brush to make the stroke wider. Then lift your brush directly off the paper.

Three-quarter Lighting: Step 7. Now comes the shadow under the lip. Starting back at the main shadow, below the mouth on the right, make a separate, curving stroke to indicate the underside of the lower lip. This stroke is not as long as the mouth indication, but it should be a bit wider.

Three-quarter Lighting: Step 8. To wrap this up, indicate the second eye form with a short, full stroke on the left side of the face, opposite the first eye shadow. Make this a very simple short stroke, not an attempt at the actual eyelids, etc. In this illustration, I've added the ears, to make the head more complete. You can block in the ear on the left side of the face with one stroke of your first light wash. As the finishing touch, you can make one or two shadow indications for the darker right ear form, and we're done!

2 Head in Side Lighting

Our first demonstration was concerned with the most common lighting situation. Most commercial portrait artists use three-quarter lighting. This doesn't mean, however, that three-quarter is the best and most desirable lighting situation. Each lighting situation has its own particular merits, and we'll explore these as we get deeper into the subject of painting portraits.

In this demonstration we'll deal with side lighting, the easiest of all the various lighting situations to represent. Side lighting creates fewer shadow shapes than three-quarter lighting and doesn't require the rather subtle value changes that are necessary in front, back, and rim lighting.

For this exercise, you'll need the same materials that you used in the first demonstration, including the fairly smooth, good quality watercolor paper. Pin a piece of paper to your board. (In the previous demonstration, I suggested cutting a full sheet of paper into eight parts, so this piece should be roughly 6″ x 8″.)

If you feel more confident with a pencil guide, rough in an oval about 5″ high before beginning Step 1. You might also find it helpful to mark very lightly, with a Number 2 pencil, the position of the eyes, nose tip, and mouth. Remember that your pencil sketches should be only the roughest guide for the brush. Since you are not painting shadows on a *particular* head, it doesn't matter if you make the nose too long or the chin too short. You'll certainly make pencil sketches in the more advanced exercises, but here, with very simple ovals, they aren't really necessary.

To begin, prepare a light wash from the ivory black and water. If you have a pile of dried paint on your palette, let the palette sit in water for a few minutes, with the paint at least partially submerged. This should soften it up nicely and make it workable. Otherwise, squeeze out a fresh pile of paint. Remember, you can't judge the value of the wash on your palette until you are quite experienced, so it's a good idea to have a separate piece of paper handy to test your washes. Keep in mind also that your wash will dry lighter—so don't make your puddle too light.

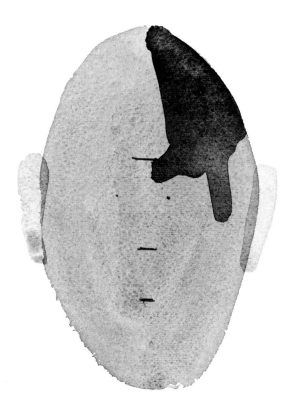

Side Lighting: Step 1. After mixing the paint and water into a fairly light value, load your brush from the puddle and give it a good shake. Brush in an oval, using broad, free strokes. Don't worry if the wash isn't even—some areas may be darker than others, but it doesn't matter. (At this point, you can also indicate both ears, with two simple strokes.) Let the wash dry.

Side Lighting: Step 2. Now, prepare a shadow wash that's much darker than the light wash; use a bit more pigment and a bit less water. Next, take a well-loaded brush, give it a good shake, and start blocking in the forehead area on the right with a downward, diagonal stroke that goes about a third of the way down the length of the face and covers about one-third of its width. Then, make a very short jog to the left to describe the general construction of the nose bridge where it meets the eyebrow.

Side Lighting: Step 3. Now comes the nose. Reload your brush, and, from the nose bridge, make a diagonal stroke to the right about one-third the length of the head. At the tip, make another very short diagonal jog in the opposite direction. To describe the bottom plane of the nose, use this darker value to indicate the ear in shadow on the right side of the face.

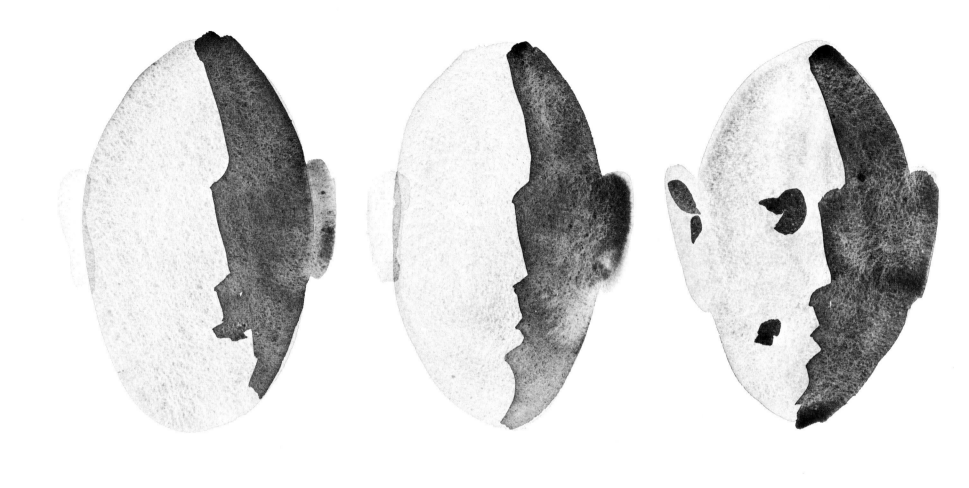

Side Lighting: Step 4. Now for the area above the mouth. Starting at the bottom plane of the nose, make a diagonal stroke to the right, just as you did for the nose and the forehead; but, this time, make it very short— say, about half a nose length. You're now at the mouth, and a very short jog toward your left will indicate the underside of the upper lip. Notice that I've used my shadow wash to lenghthen the shadow along the right side of the face.

Side Lighting: Step 5. The lower lip comes next. It might well be catching some light, so cut back your brush to the right from the underside of the upper lip to leave a light area. Then make a shadow under the lower lip with a short diagonal stroke to your left. Finally, make a simple stroke that curves outward to the right and back down around the bulge of the chin.

Side Lighting: Step 6. For your finishing touches, show the shadow areas in the left ear and eye, the left portion of the nose, and the left corner of the mouth. Note that these small shadow areas are little more than large dots. Make no attempt to be accurate with these shapes. All you want at this point is a generalization, to give an idea of a simple, solid-looking head.

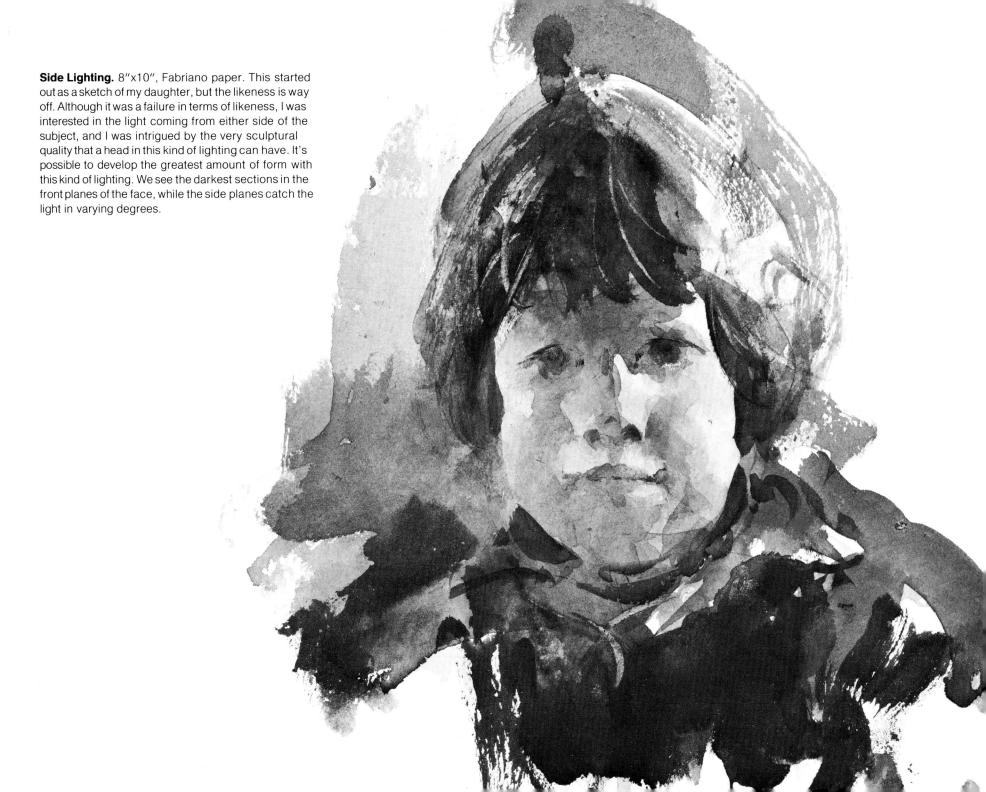

Side Lighting. 8″x10″, Fabriano paper. This started out as a sketch of my daughter, but the likeness is way off. Although it was a failure in terms of likeness, I was interested in the light coming from either side of the subject, and I was intrigued by the very sculptural quality that a head in this kind of lighting can have. It's possible to develop the greatest amount of form with this kind of lighting. We see the darkest sections in the front planes of the face, while the side planes catch the light in varying degrees.

3
Head in Front Lighting

Front lighting is difficult to represent, because it does not create simple shadow shapes to clearly show the construction of head. Instead of relying on simple shadow shapes, we must describe the head with *small* shadow shapes and *halftones*, or the values which lie between lights and shadows. Halftones require much more subtle treatment than the simple statements of light and shadow which you made in the first two demonstrations.

However, since we're still dealing with very basic head forms, we'll rely as much as possible on the small shadow shapes and keep our use of halftones to a minimum. Later, when we're involved with more "finished" heads, halftones will play a much larger part; but, for now, we'll stay with basics and develop a simple, solid head with small shadow shapes.

For this exercise, stick with the the materials you've been using. You'll also need a box of tissues. Pin a new piece of paper to your board. We'll assume that the light is coming from the front and slightly above the head, so there'll be shadows on both the *right* and *left* side planes, as well as *under* the features.

Front Lighting: Step 1. By now you should be more adept at painting simple ovals, so a pencil guide shouldn't really be necessary. Squeeze out a small amount of the black pigment, mix a puddle of fairly light wash, and make a simple oval shape about 5″ high. Allow it to dry.

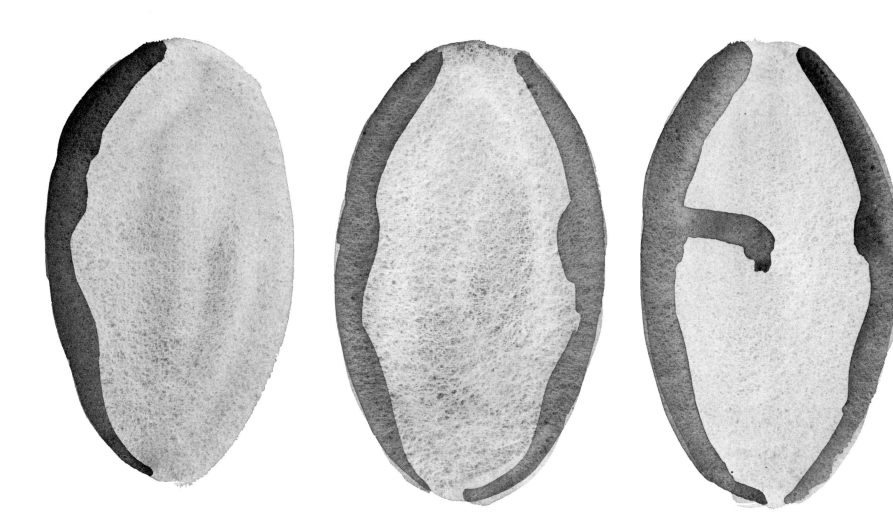

Front Lighting: Step 2. Mix your shadow wash—with more pigment, less water this time—and block in the left side plane. Notice how the contours of the shadow follow the shape of the forehead. Work broadly, but keep in mind the placement and shapes of the forehead, eyes, cheeks, and chin as you work in those areas.

Front Lighting: Step 3. Now, repeat the same procedure on the right side of the head. For now, stick with the same shadow shapes on both sides of the head. Later, you'll see that the side planes of the face usually differ from each other and are rarely both indicated with the same shadow shapes.

Front Lighting: Step 4. Now come the bottom planes of the eyebrows, nose, and mouth. These are not as prominent in front lighting as they are in overhead lighting, but they're still quite definite. Starting one-third of the way down either side shadow (I've started on the left), make a horizontal stroke directly across the face, stop just short of the halfway point, and make a short jog downward.

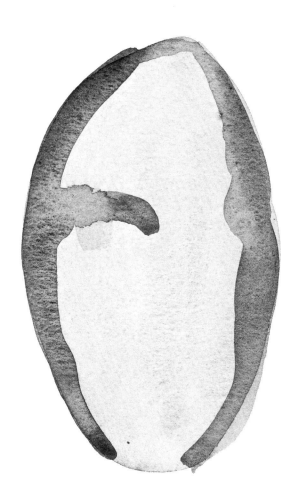

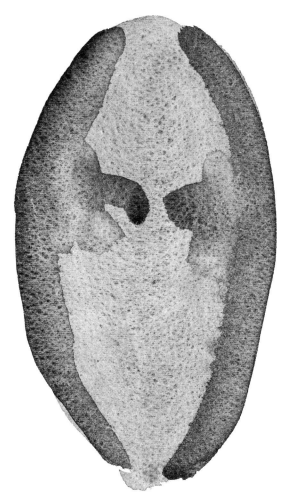

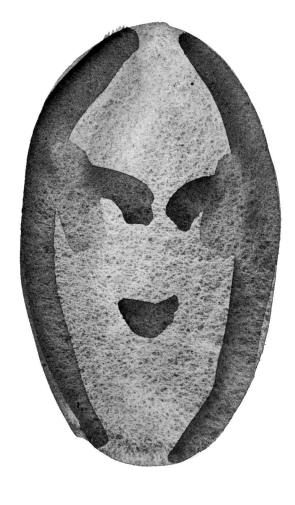

Front Lighting: Step 5. Rinse out your brush and give it a good shake. Pass the damp brush downward through the stroke you made in Step 4 to indicate the side of the eye.

Front Lighting: Step 6. Repeat Steps 4 and 5, starting from the shadow on the other side of the face. Obviously, the eyes are much more complicated than this; but you've made a good start in indicating the structure of the eyeball and socket.

Front Lighting: Step 7. With one stroke, make a simple, dark, triangular shape about two-thirds of the way down the center of the face. This indicates the bottom plane of the nose.

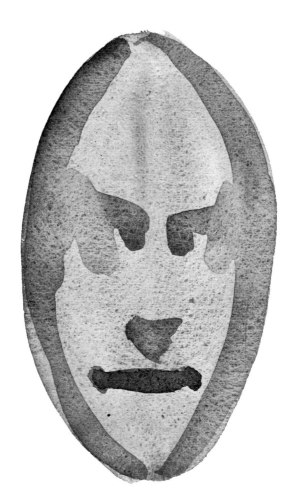

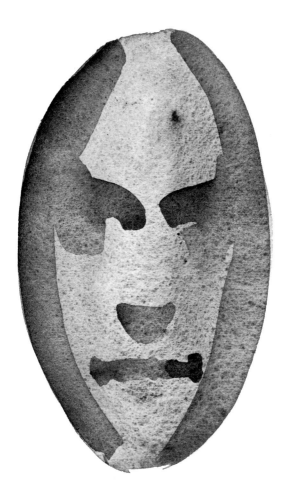

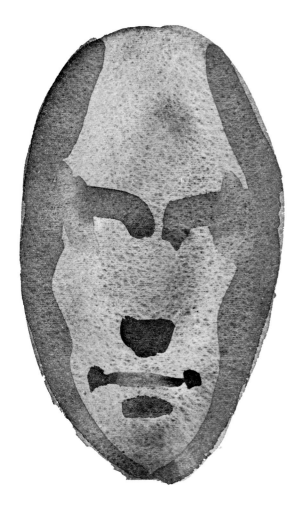

Front Lighting: Step 8. The upper lip has a definite shape and can't really be shown with a simple line across the face. To indicate the mouth, start a fairly broad stroke in the middle of it. As you move to one side and then to the other, make the stroke narrower immediately, and put less pressure on the brush. At the corners of the mouth, press the brush down and lift it directly off the paper.

Front Lighting: Step 9. Quickly blot the whole center section of the mouth with a tissue to lighten it.

Front Lighting: Step 10. To finish, make a short stroke under the mouth.

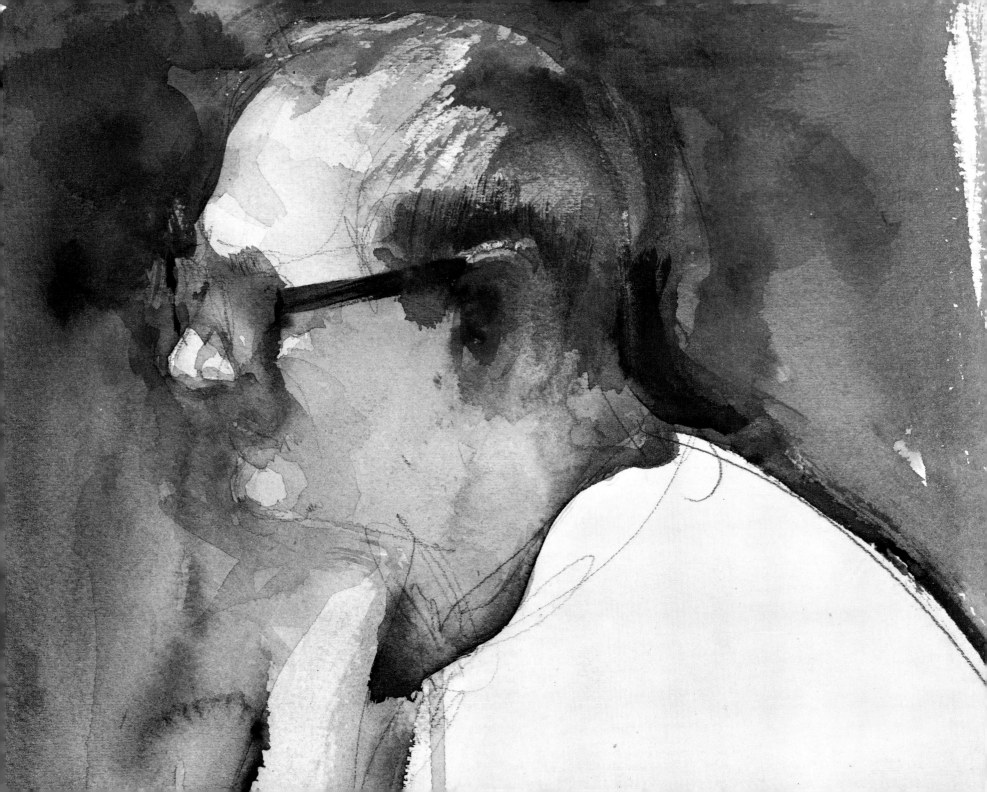

Joe. (Left) 10″x10″, Fabriano paper. This is a painting of a very good friend. I was particularly intrigued by the very strong overhead light and I really went overboard in allowing my shadows to become blurred and lost, relying on the few light-struck areas to carry the picture. I left the initial wash, which I usually use to describe my light areas, very high in key. I wanted the slightly washed-out, cold effect that the strong fluorescent lights produced.

Standing Figure. (Right) 8″x10″, Fabriano paper. In this case, the head didn't interest me as much as the pattern that the light created when it struck the girl's shoulder blade and the front of her shoulder. Most of the figure and background are in shadow, and you can see just the barest indication of light as it skims around the head and describes the boundary of forehead, nose and mouth. Although the values in this background are much darker than the values in the figure, I often use the same value in both areas, and I occasionally use some of the same colors. I enjoy experimenting with values. I'm never sure just how I'll paint a subject until I experiment. When I work in oil I constantly change my values. When I work in watercolor, I sometimes make three or four studies such as this, experimenting with dark values in one and light values in another. Each time you change a value, you create a different effect. If I had made the background darker in this painting, the feeling would be totally different.

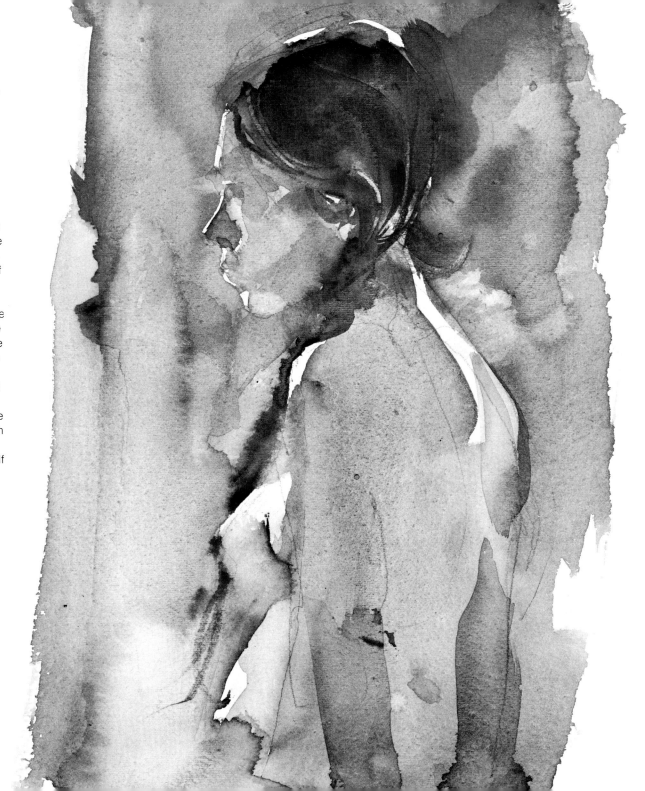

4
Head in Back Lighting

When the light source is somewhere behind the head, the situation is called *back lighting*. With the light at the right side, and only *slightly* behind the head, the shadow pattern is similar to that in Sketch A. If the light is almost *directly* behind the head but slightly off to the right, the head looks something like Sketch B. When the light is *directly* behind the head, there is a simple, dark silhouette, with little or no rim light showing, as in Sketch C. (We'll discuss rim lighting in the next exercise.)

For this exercise, we'll assume that the head is lighted as in Sketch A, with the light on the right side and only slightly behind the head. In this back lighting situation, most of the face remains in shadow; these shadow shapes are quite descriptive of the head as well as rather simple to paint.

As you mix a light wash, and then a much darker shadow wash for this exercise, remember to check your values on another piece of paper. This way, you won't overwork the washes on your painting by restating values. Also, remember to dip your brush in your water supply and give it a shake before you load it with a new value—in this case, your shadow value. Make your strokes decisive and broad and block in your shadows fairly quickly, so that you'll be able to soften and "grade" certain areas. You'll see what I mean as we go along.

Again, you'll use your ivory black, a Number 8 brush, a jar of clean water, your sheets of good quality, fairly smooth watercolor paper, a palette, pushpins and drawing board, and a Number 2 office pencil.

A. This shadow pattern occurs when the light is at the right side and only slightly behind the head.

B. When the light is almost directly behind the head, but slightly off to the right, the shadows look like this.

C. Here, the light is directly behind the head, ar a simple, dark silhouette is created.

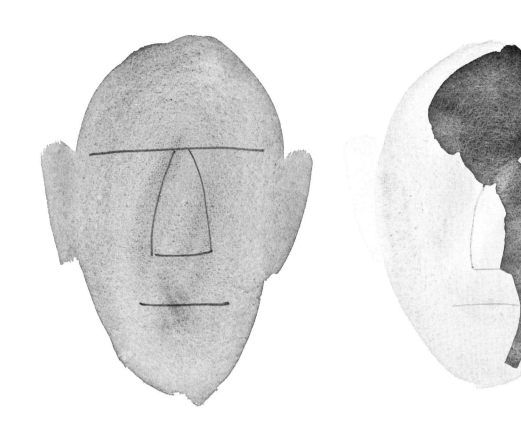

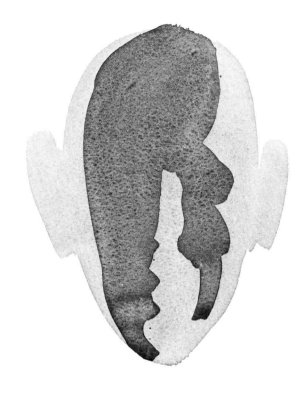

Back Lighting: Step 1. Paint a fairly light oval, about 6″ high, including one stroke for each ear. Allow it to dry. Then, with your pencil, make a line across the face about one-third of the way down. This is the line of the eyes. Directly under it, draw a triangular shape for the nose. Note that the sides of this triangle are made up of two curving lines, and that the bottom is about two-thirds of the way down the face. Indicate the mouth with a line halfway between the bottom of the triangle and the bottom of the head form.

Back Lighting: Step 2. With a dark shadow wash, start blocking in the shadow shapes. (I usually start blocking about two-thirds of the way across the forehead, on the right, or lighter, side of the face.) After you block in the shadow on the forehead, continue the stroke down on the right, making a dark shape beside the nose to indicate that part of the eye socket on this side is in shadow. The top plane of the cheek is probably catching some light, so narrow your stroke in toward the nose and leave this area untouched by shadow wash. Broaden again for the bottom plane of the cheek. Then narrow your Stroke and curve it to the right for the area above the upper lip—around the rounded thrust of the teeth—which is probably also catching light. Curve your stroke inward and downward toward the chin in a single, broad line.

Back Lighting: Step 3. Block in the shadows in the left-center section, leaving a light strip about ¾″ wide along the left boundary of the face. Work quickly and mass in the shadows, starting with the forehead and the top of the nose. Fill in the left side of the nose, working down toward the tip, and make a small jog to the right when you get there. Then, roughly indicate the contours of the upper and lower lips and the curve of the chin. Don't worry if these contours aren't correct. This should be just a facsimile of a face.

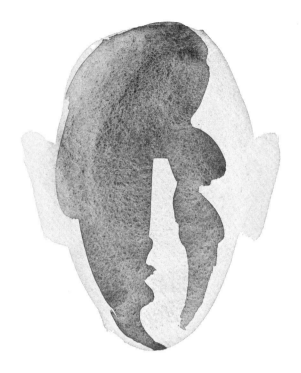

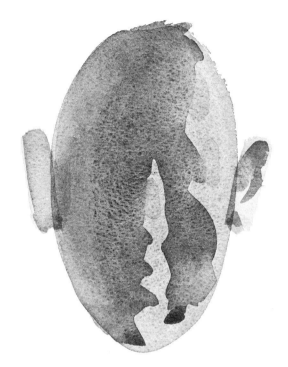

Back Lighting: Step 4. Now draw the shadow wash out further toward the left side of the head. You should have enough paint and water in your brush to do this without going back to the paint supply on your palette. Draw this shadow right out to the edge of the head and indicate the contour of the ear.

Back Lighting: Step 5. Now to suggest reflected light within the shadow. The shadow should still be wet for this step. Rinse your brush in your water supply and give it several good shakes to make it just damp. Then start a downward zigzag stroke at the top of the light strip on the outer left side of the head. (See the sketch at the right on this page.) Allow the shadow wash to flow out in a slightly lighter value along this strip. This lighter area suggests reflected light and gives the head a feeling of bulk and three-dimensional form. You might have to repeat this process several times, and the area of reflected light will become lighter and lighter with each of your strokes. Remember that you're using your brush as a sponge: you're no longer putting paint on, you're taking paint off.

To suggest reflected light within the shadow, place a damp brush at the top of the light strip at the left, and draw the brush downward in a zigzag stroke.

Back Lighting. (Right) 8"x10", Fabriano paper. This model was sitting in front of a window and most of the light was coming from behind. However, the light was so strong that there was a great deal of reflected light in the room, and I showed this with very high-keyed shadows. Only the cheekbone and the side of the eye were affected by the light, but I cheated a bit and added some light-struck sections on the nose and above the mouth to make the form more interesting. There's also a very tiny spot of light on the lower lip. Although I indicated the very subtle darkening in the mouth area, it's these light-struck sections of the mouth that actually show that it's there.

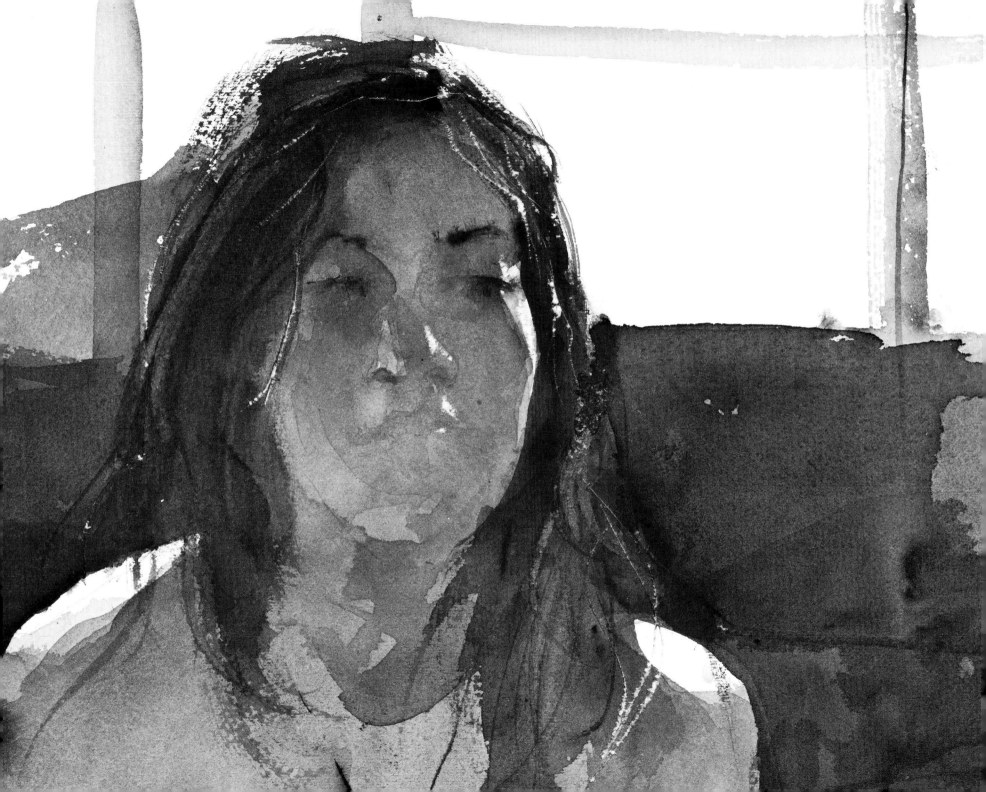

5
Head in Rim Lighting

The differences between back lighting and rim lighting are very subtle, and the effects of both lighting situations are quite similar. When there is at least one light *behind* the head and a secondary light coming from one or both *sides* of the head, we see a definite rim of light around the border of the dark shadow. This secondary light brings out subtle value changes in the front of the face, and the problem of shadows becomes more complicated. In the sketch below, notice how much form we see when there are two lights behind and one on either side of the head.

In this case—and whenever you're trying to determine the overall, or "big" shadow value—squint as you look at the subject. When you use this trick, the complicated small forms disappear and you see the big, simple shape of a dark silhouette with a light rim around it. One of the greatest problems students have is seeing too much, rather than too little. Perhaps I could say that a student sees too many of the "wrong" things—too many of the unimportant details.

For this exercise, we'll use the rim lighting situation in the sketch—with two lights behind, and one on either side of the head. Don't worry about all the small forms you might see in the shadow that covers the front of the face. You'll need the same materials you've been using: ivory black, a Number 8 watercolor brush, pieces of good quality, fairly smooth watercolor paper, water jar and water, pushpins and drawing board.

When there is at least one light behind the head, and a secondary light coming from one or both sides of the head, we see a rim lighting pattern similar to this.

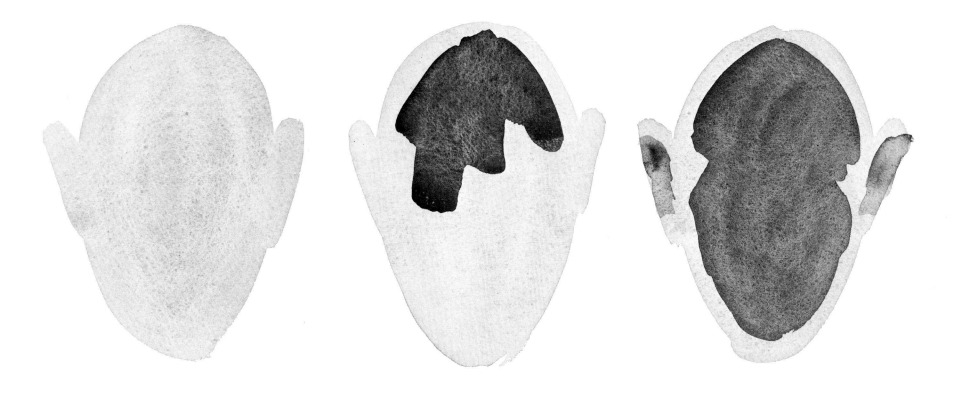

Rim Lighting: Step 1. You should be able to paint the first, light-valued oval without an outline, so pencil work isn't necessary before you start painting. Mix a fairly light wash on your palette and paint a simple oval about 5″ high. Now, make two short, diagonal strokes about a third of the way down the head to indicate the ears. Allow this wash to dry.

Rim Lighting: Step 2. Mix up a darker wash on your palette, using more of the black pigment, this time with less water. Give your brush a good shake after cleaning it in the water supply, and shake it again after loading it from the darker puddle. As I've already discussed, most of the face is a simple dark value, so, beginning about ¼″ from the top of the light oval, start blocking in the shadows. Work broadly, making bold strokes, first downward in the center, then branching off to the sides.

Rim Lighting: Step 3. Try to visualize and roughly indicate the construction of the eye sockets and cheek bones as you block in this area. As you work out toward the side boundaries of the shadow, remember that they are the boundaries of the front plane of the face and roughly indicate those contours. Next, block in the shadow sections of both ears, leaving a rim of light. You should now have a rim of light completely surrounding the face.

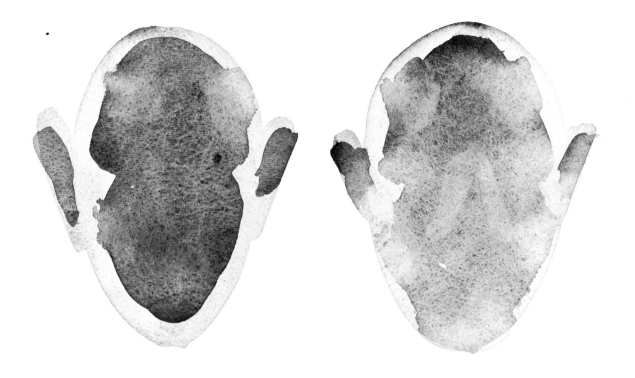

Rim Lighting: Step 4. While this front plane shadow is still wet, rinse out your brush, give it a good shake, and start softening some of the boundaries between the shadow and the light rim with zigzag strokes. Where you soften an edge really depends on the particular head and the exact postion of the lights behind and beside it. In this demonstration, I've softened all the bottom and side planes but this is only an arbitrary decision. When you're painting an actual head, observe where the shadows on these forms seem to soften and where they appear harder.

Rim Lighting: Step 5. To finish your head, soften the lower boundary of the chin. The neck stops the light from reaching this area, leaving it in shadow. Remember that the areas you soften between the shadow and the light rim should actually appear *lighter* than the light rim itself. You can make them lighter by blotting them with a tissue, or by mopping them with a clean, damp brush. As a final touch, blot the side planes of the nose with a brush that's just damp, not really wet. Make this just a subtle indication—we don't want to complicate the face!

Blue Head. (Right) 12″x12″, Fabriano paper. This subject had very delicate and lovely skintones, and I spent most of my time just mixing up the right complexion values on my palette. I did paint the entire head with a light wash first and allowed it to dry before I added my shadows. In this dim lighting situation, however, I could have used the white paper alone to indicate the light-struck areas. Notice that I hardly stated the eye. There's just a subtle indication to show that it's there.

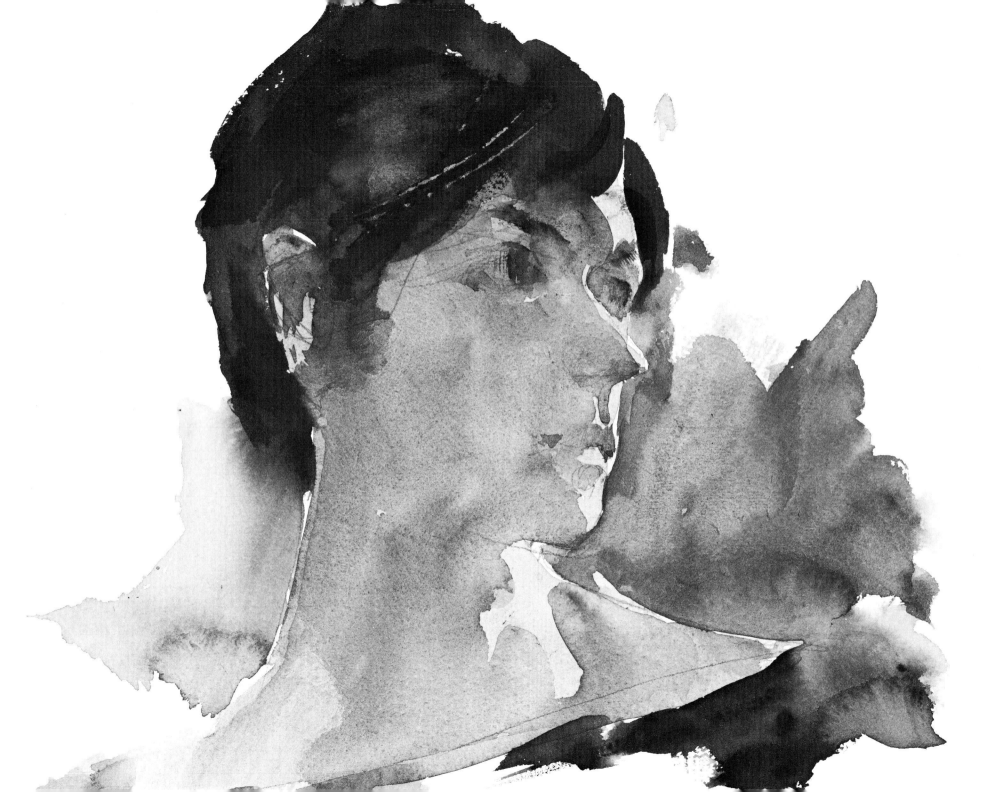

6
Basic
Head
Form

So far, you've been painting basic head forms with two major values: light and shadow, But, when you softened an edge between light and shadow, you created a third, or middle, value. Because it's supposed to be a value somewhere between light and shadow, this middle value is sometimes called "halftone."

In this demonstration, we're going to give more emphasis to the middle value or halftone. I'd like to stress, however, that the two original values, light and shadow, are still of prime importance. If you confuse your shadows by making them too light or too busy (with lots of small value changes within these shadows) or if you clutter your lights up with values that are too dark, you'll destroy the simple form of the head. Keep this in mind, and as you work on your middle tones, don't let them destroy your simple lights and darks.

Naturally, when you're working with a specific model, the shadows created will vary in width and length, depending on the contours of the head, as well as on your lighting situation. You won't always find the same pattern of hard and soft edges. Here, we'll just do a very generalized head, but the principles of halftone we deal with in this exercise should be adapted for, and applied to, any head you choose to paint.

This time, we'll assume that the light is coming from above and to the right of the head. You'll need your Number 8 watercolor brush, a palette, a tube of ivory black, water jar and clean water, pieces of watercolor paper, pushpins, and drawing board. Always keep tissues handy, to lighten, soften, or lift out wet washes.

Basic Head: Step 1. For the sake of variety, we'll do a three-quarter-view head. This is really the same basic oval. It's just a bit flatter on one side, a little more curved on the other. Mix your usual light wash and block in an oval 5''' high, similar in shape to the one illustrated. Don't worry too much about making an exact copy of my oval.

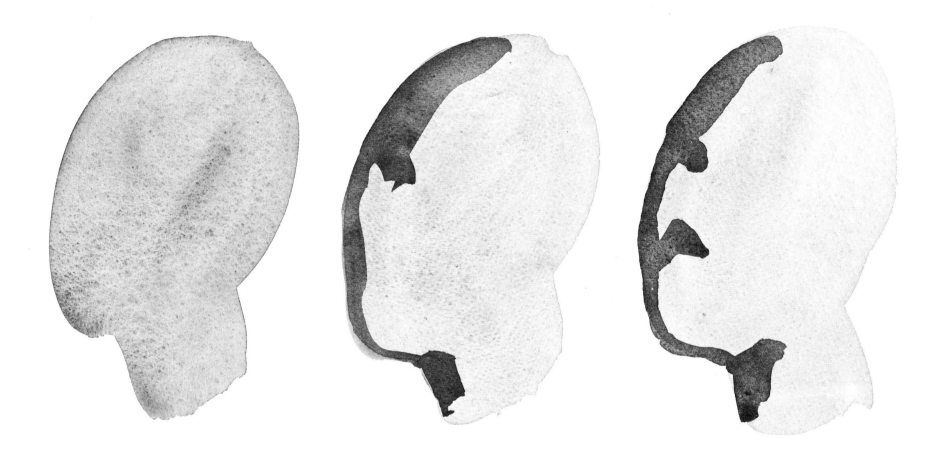

Basic Head: Step 2. Now for the neck. While the first wash is still good and wet, start about 1 ½″ in from the chin, and make a rectangular shape about 2″ wide and 2″ long.

Basic Head: Step 3. Mix up your shadow value on your palette. After getting rid of excess moisture with a shake of the brush, start blocking in a dark shadow strip about 1″ wide along the left side of the face. At what will be the eye area, make a slight jog to the right and stop, to indicate the eye socket. Then, with a much thinner stroke (about ½″ wide), continue to follow the left boundary of the oval around to the neck. Notice that this strip becomes very narrow below the eye and then widens again at the neck.

Basic Head: Step 4. While this shadow strip is still wet, draw it out to make the bottom plane of the nose. This is a simple triangle shape, and one corner of the triangle blends with the shadow strip.

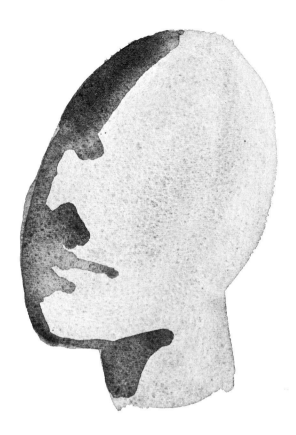

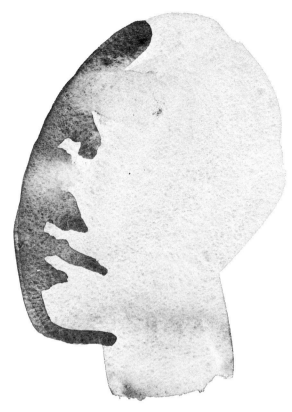

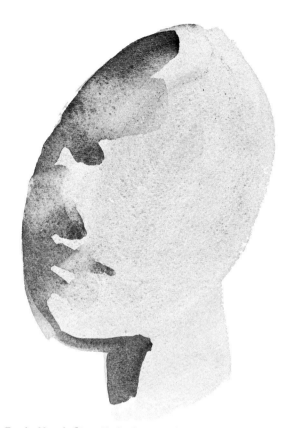

Basic Head: Step 5. Now, reload your brush from the shadow puddle, give it a shake, and move on to the mouth. Once again, start at the shadow, which should still be wet, and brush the shadow shapes out into the light area. Indicate the upper lip with a general shadow shape about 1¼" long. The top plane of the lower lip catches light and creates a shadow under it; so don't really touch the lower lip itself, but make a shadow under it about ¾" long. The shadow under the lower lip is quite wide where it joins the main shadow, but it narrows as it proceeds out into the light area.

Basic Head: Step 6. Your shadow should still be wet when you do this step. Don't put in any new shadows now, but "connect" the ones you have with your light areas, to make a third, or middle, value. For this general diagram, leave about 1" at the top of the shadow strip "hard." Rinse your brush, give it a good, hard shake, and place it in the shadow above the eye. Now, soften the forehead by drawing your brush outward and slightly upward about 1" into the light area. Prepare your brush again, and soften the edge of the stroke you just made. Repeat this procedure until you have a smooth gradation from light to shadow. A tissue is handy here to blot the end of the stroke—to make it light enough and to get rid of excess water. Now, use the same procedure on the shadow of the cheek and the top section of the nose.

Basic Head: Step 7. At the mouth, you want to show that the lips curve *around* the dental arch of the teeth. One way to do this is to lighten and soften the edge of the lips as I've done in my illustration. Rinse your brush, shake it, and draw it right up *through* the mouth in a diagonal stroke. Again, you can blot this area with your tissue. (You'll have to experiment. All this takes practice. The first few times you try, you probably won't get the effect you want, so be patient.) Finally, soften the shadow under the mouth, using the same procedure. You should now see a very definite combination of hard and soft edges.

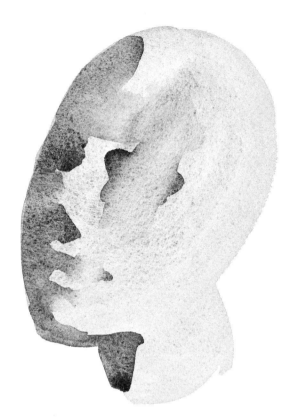

Basic Head: Step 8. Now for the right eye. In the light area, use your shadow value to paint an oval about 1½" long and 1" high. Rinse and shake your brush and lighten the middle section of the eye to show the round form of the eyeball and give the eye a feeling of bulk. If necessary, blot this mid-section carefully with a tissue to lighten it. Note that there are hard edges on either side of the eye and soft edges in the middle. Now, continue the middle, light area of the right eye down through the top plane of the cheek. This area is about ¾" wide directly under the eye, but it widens as you approach the bottom plane of the cheek.

Basic Head: Step 9. To end your project, reload your brush, shake it out and, starting at the right corner of the mouth, make a very *short* stroke upward toward the cheek. Now, rinse your brush, give it a very good shake, and allow this dark area to flow upward, to show the bottom plane of the cheek. Work this middle value down into the lower cheek, toward the upper lip, and into the shadow below the lower lip. Then, indicate the right ear very simply, with an oblong shape. Note that the ear in this illustration is quite light, because I've blotted it with my tissue to keep it fairly light and unimportant. We'll worry more about the ears later.

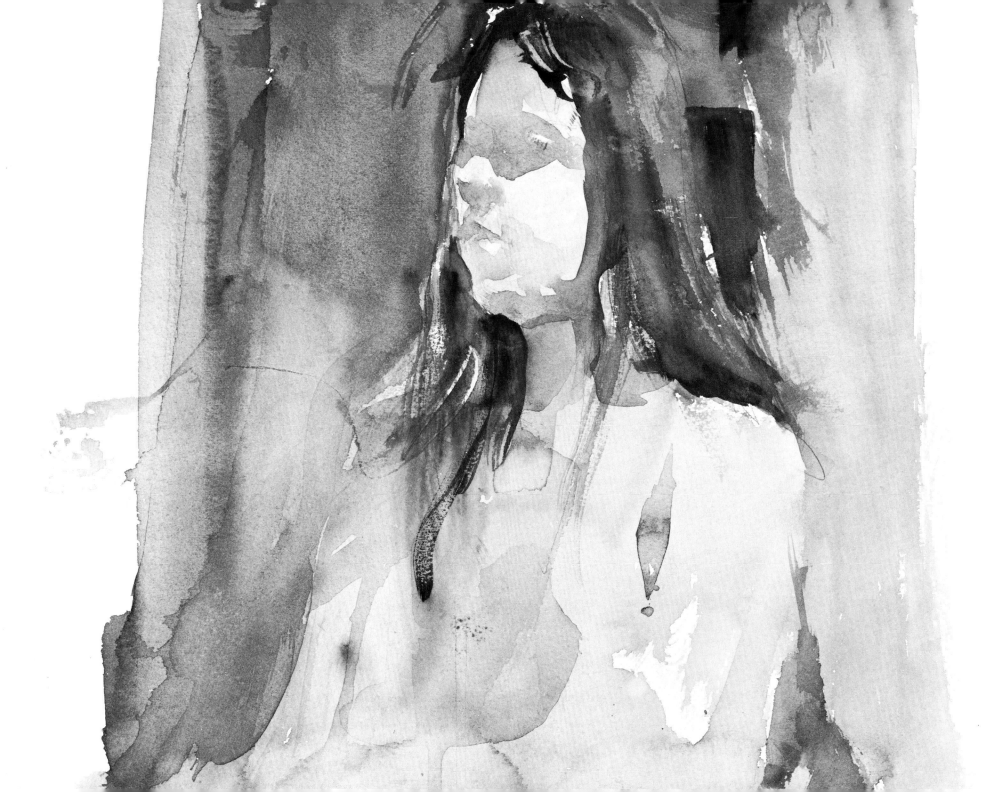

The Features

Seated Model. 10″x10″, Fabriano paper. The very simple lighting on this head created a very nice feeling of bulk and form. The model had very fair complexion, and the tones were extremely cool. The shadows were mostly cerulean blue, except for the nose, which was quite warm. I actually exaggerated the coolness of the shadows in the eyes and around the mouth, just as I exaggerated the warmth of the nose, to make the color in the head a bit more interesting.

7
Eyes

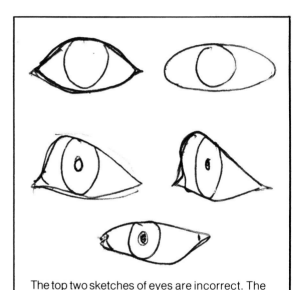

The top two sketches of eyes are incorrect. The upper and lower lids should never be drawn as identical shapes. The three lower sketches will give you an idea of the variations in shape found between the upper and lower lids.

In the previous demonstrations, as you studied the overall construction of the head, I stressed the importance of showing that the head has bulk and form—a lesson that you should always keep in mind. Unfortunately, however, it's much easier to think *form* when you're working on a generalized head than when you're painting a specific head. When it comes to painting the head of a particular person, you'll have a strong tendency to forget all about overall bulk and mass and to concentrate instead on the particular features that you think will give you a likeness.

However, a good likeness actually depends more on the construction of the particular head than it does on the small shape changes found in an eye or mouth. This is a vital point, and I wish I could somehow cement it solidly into your mind: but it's a very difficult concept to practice, and only through experience, with its tears and frustration, will you finally understand!

As you start painting particular features in this exercise, try to stick with the feeling of bulk and mass that you've been practicing. Although you'll be putting in eyelids and eyebrows this time, continue to strive for a general impression of form and three-dimensional bulk.

In this demonstration, you'll be working on the right eye (the eye on the right, from *your* point of view), on a three-quarter view of the head, illumi-

nated by a single light source from slightly *above* and to the *right*.

As you begin Step 1, note the shape of the eye I've drawn. Notice the rather angular shape of the left side of the upper lid. Remember that the shape of the eye is never general. Its curves always have a specific shape, depending on the particular model you're using and on the position of the eye in relation to you. An eye viewed from the front naturally appears to have a different shape than does an eye in three-quarter or side view. And, most important, remember that the upper and lower lids never have identical shapes. They are never identical almonds or ovals; the upper lid normally overlaps the iris, which usually seems to be "sitting" on the lower lid. In the sketch at the left, I've drawn some "good" and "bad" eye shapes.

You'll be using the same materials: ivory black, Number 8 watercolor brush, 6″ x 8″ watercolor paper, water jar and clean water, pushpins and drawing board. This time, you'll be making some light pencil indications again, so have your 2B graphite pencil handy.

One final point before starting. For demonstration purposes, you'll be doing features by themselves in the following projects. However, when you're actually painting a complete head, always consider the features in relation to each other and to the head as a whole—never by themselves.

Eyes: Step 1. Lightly sketch in an eye about 1½″ long and ¾″ high at its highest point, using the shape in my illustration as an example.

Eyes: Step 2. Mix up a light wash, pass it over the whole area of your drawing, and allow it to dry. Then, mix up your shadow wash.

Eyes: Step 3. Starting about ¾″ above the upper lid, in a line parallel to the left boundary of the iris, make a diagonal shadow stroke downward. Notice that I've painted right over the left boundary of the eye.

Eyes: Step 4. While your dark strip is still wet, begin to soften the edges. Allow the wash to flow out at the nose bridge to indicate a front plane between the top plane of the nose and the top plane of the forehead. Also, allow some darker wash to flow out into the eyeball and under the lower lid. It's important that you don't worry about the actual boundaries of the eye, but, instead, try to show the big planes of the eyeball and the adjacent nose area.

Eyes: Step 5. Continue to draw your shadow "out." Indicate the shadow on the upper lid simply, with a long stroke that runs the entire length of the upper lid. Blot this stroke lightly just above the iris to lighten this area and to show that the eyeball and upper lid "come out at us" at this point.

Eyes: Step 6. While the wash is still wet, blot and lighten the lower left, or inside corner of the eye. After you blot, you might have to draw more shadow out into the light and restate the specific boundary of the corner of the eye. Now comes the important large oval plane on the right side of the eye (your right). Again, make a simple, diagonal dark stroke, beginning above the upper lid and stopping just below the right corner of the eye. Finally, soften the upper boundary of this diagonal stroke with a damp brush and blot it if necessary. You should now have the feeling of the contour of the eyeball.

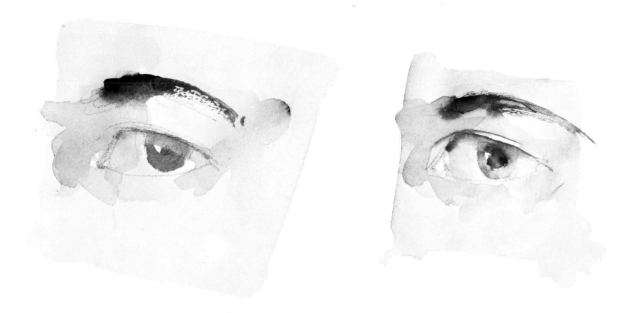

Eyes: Step 7. Now for the eyebrow. Hopefully, the darker wash is still damp, since you want to put some soft edges on the eyebrow. Use almost pure pigment here, and start at the left, thicker end of the eyebrow, where the edges should be soft. As the eyebrow curves around the side plane of the forehead, your stroke should become lighter and thinner. Here, you might try drybrush to suggest the lightening and thinning, as well as to suggest the texture of the eyebrow. Finally, block in a simple oval for the iris, with the value you used in the upper lid. (In many cases, you might want to use the same value in all three areas—iris, upper lid, *and* eyebrow.) I've left a small dot untouched in the iris, as a highlight. Remember—never make highlights too large or important. Leave them out rather than overdo them. Note that some boundaries of the iris have blended with adjacent areas and softened. *Never* fill in a hard oval here: let the iris "bleed" out into the eye in places, keeping the tissue handy to control the "bleed."

Eyes: Step 8. The iris should still be damp. Using a touch of pure pigment—almost no water—"drop" in the dark pupil, still leaving the highlight untouched. Next, block in a darker strip on the upper lid. As a rule, the upper lid is always darker than the lower lid, since it forms a bottom plane and casts a shadow on the eyeball. (Eye make-ups that women might use should not concern you here. They are exceptions to a rule that usually applies.) I've also made a simple curving line as a general indication of the fold directly above the eye. When you paint a particular eye, however, give special attention to the shape of this fold. Finally, restate some of the darks around the eye. For this final step, allow the previous washes to dry, so you can see exactly what needs more definition and restatement. Never try to work a new wash over one that is still damp. In my final sketch, there are many "lost" and "found" edges, and the eye has definition without looking hard.

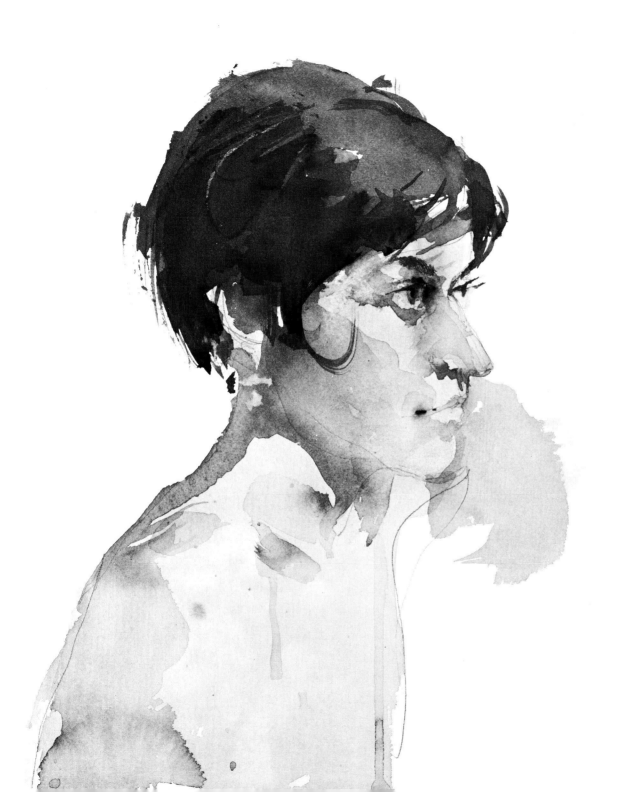

Vicky. (Left) 8″x10″, Fabriano paper. This is one of those paintings that turn out to be quite a good likeness even though I'm not overly concerned with a likeness. I did it in a sketch class, and a very strong light was shining on the model. This girl has very definite features—lovely eyes and a very strong, aquiline nose. I painted the head in two values, washing in the light value first and—after this dried—blocking in the darker value very simply. Finally, I added the dark accents around the eyes, which are quite prominent. When a subject has prominent eyes, it's very important to stress them and to let other areas, such as the mouth in this case, become secondary. Here, I let the eyes and the hair dominate the painting.

Doris. (Right) 12″x12″, Fabriano paper. This model had very strong features, and I found it quite simple to capture the likeness. She was sitting still, which also helped a great deal. The strength of the particular features—the very characteristic mouth and the definite eyes and nose—in connection with the simple shadow shapes created by the strong lighting situation made the head quite simple to do.

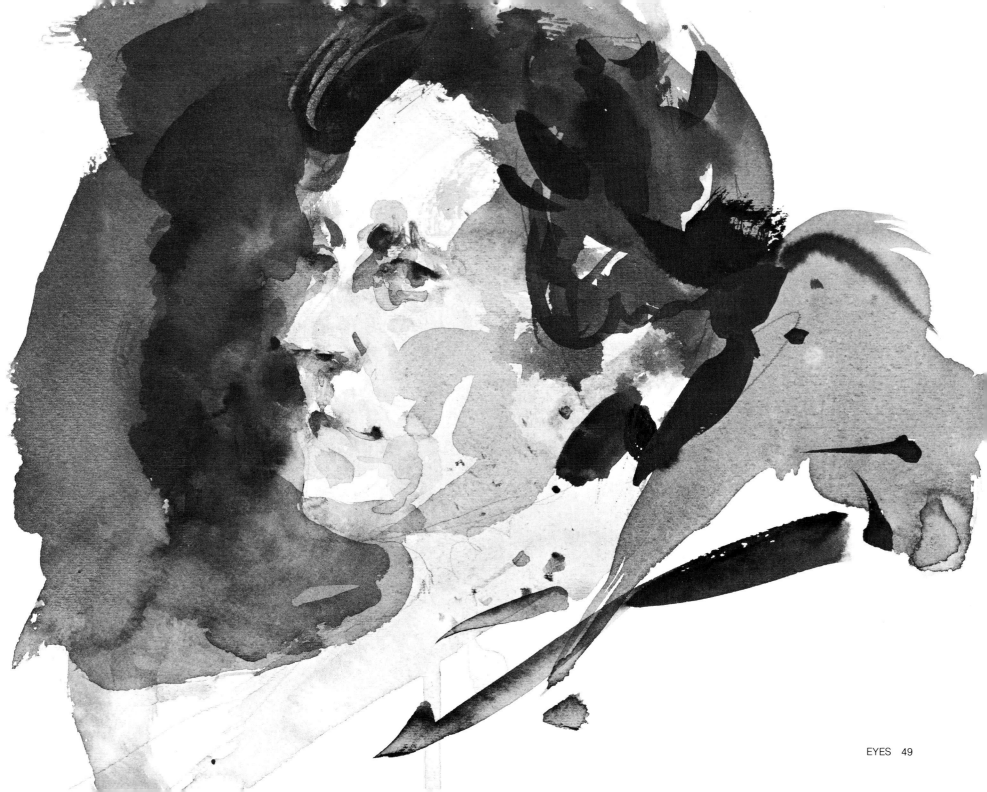

8
Nose

Each feature has its own set of painting problems, and the nose is no exception. As portrait painter John Singer Sargent once commented: "A definition of a portrait is that there is something wrong with the nose." Although describing *shape* accurately with light, dark, and middle values is a problem common to painting all the features, one aspect of this problem is somewhat unique to painting the nose: subtle value changes are also necessary to indicate shape in the part of the nose that is *in light*.

Like the head, the nose is made up of specific planes: those facing the light are naturally the lightest; those turned partially away from the light are a bit darker; and those planes turned completely away from the light are in shadow. As you'll see, the shadow area of the nose is easy enough to block in. However, this dark area does–'t completely explain the nose, and we must go out into the *light* area with *middle light* values to develop the full construction.

As you do this, guard against making these "light" indications too dark, or you'll destroy the form of the nose, as well as the form of the entire head. In this demonstration, put in only the most *necessary* middle values. No stroke should be made that isn't vital. I'm not sure who said it, but the statement, "It's what you leave out, not what you put in, that counts," certainly applies here!

As you go along, you'll also see cases in which highlights and accents are used. These are at opposite ends of the value range: highlights are the lightest lights, accents are the darkest darks. However, they have one thing in common: they should both be used sparingly and with great discretion. It's like using salt in cooking: just the right amount can be marvelous; too much, and you've ruined the dish.

Again, we'll use a good, strong, single light source that makes shadow shapes obvious. We'll assume that the light is coming from above and to the left. Hopefully, you've done enough drawing to know what shapes to look for. Each nose is different, of course, and you'll have to study specific subjects carefully to observe the particular shapes of their noses. Here, we have a three-quarter view of the nose, above eye level, so we see some of the major bottom planes.

Before you begin Step 1, notice that I've sketched in the lower section of the nose as a simple oval in my illustration. Using this basic oval as a foundation, I then describe the specific shapes of the particular nose I'm painting. Always start this way, with a general shape, such as a cylinder or an oval; then you'll have a point of departure for your specific shapes.

Try the following experiment and I think you'll see what I mean. Pretend you're looking down at an umbrella, and try to draw the series of points around the rim, just as you would see them. I think you'll find it difficult to do this very accurately. Now, draw a circle first, and using this circle as a foundation, draw the series of points. Do you see that this technique makes it much easier to draw a respectable-looking umbrella?

Back to the nose. Note the variety of shapes in the illustration for Step 1. There are angles, curves, and straight lines. Always look for—and draw—a variety of shapes. No form is made of curves alone; there are almost always some angles and straight lines, too!

You'll need your Number 8 watercolor brush, your tube of ivory black paint, a palette, water jar and clean water, pieces of 6" x 8" watercolor paper, a drawing board and pushpins, and a Number 2 pencil.

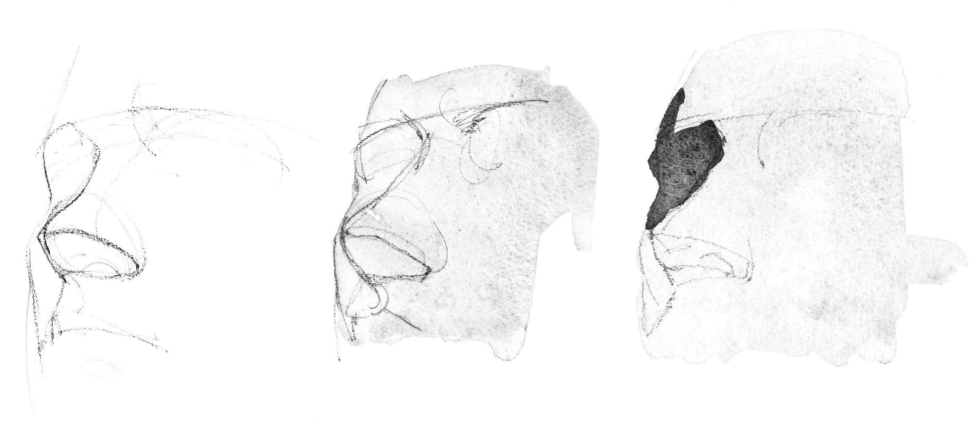

Nose: Step 1. Sketch in the nose, using the method I just discussed. In my sketch, I've included some of the surrounding features, but don't worry about these surrounding areas—they merely help to give us an idea of the position of the nose on the face. Note that I've sketched in the boundaries of the bottom plane of the nose. This will give you a guide when you block in this area with your darker values.

Nose: Step 2. Now, lay a wash over the nose and the surrounding areas. I've left one small dot of white paper untouched on the front plane of the nose. This will be the highlight. Remember that highlights should always be very small and that one or two highlights on a head are plenty.

Nose: Step 3. Now, your shadow shapes. In this case, the bottom plane of the nose and the cast shadow under the nose are the most important dark areas. After mixing up a shadow puddle on your palette, load your brush and give it a good shake. (The first light wash should be dry by now). First, block in the left eye, which silhouettes the light-struck nose. Watch your pencil guides and make your shadow shape carefully, noting the outer boundaries of the left eyebrow and cheek and, more important, making sure the boundary of the front plane of the nose is right. It's very important that you catch the subtle angles and curves of any shape you're drawing or painting, and this is certainly true in the case of the nose! Stop the stroke just short of the nose tip,

Nose: Step 4. Now for the bottom plane of the nose. The entire underside of the nose can be described with a simple, oblong shadow stroke. Then with the same wash, paint the cast shadows under the nose. These cast shadows continue right down and connect with the mouth. (Always tie in as many of your shadow shapes as you can: avoid leaving bits and pieces of shadows spread aimlessly about.) Finally, give the briefest indication of the right eye socket, to make the nose ''project'' out from the face.

Nose: Step 5. I've carried the bottom plane shadow of the nose a bit further, articulating the definite small shapes on either side of the nose tip. Normally, I'd do this when I first put in the bottom plane (Step 4), but here, I want to stress the importance of starting with big, simple shapes before getting involved with small forms. I've also carried the mouth a bit further, just to show how much mileage we can get out of the cast shadow under the nose. You can also use the same shadow wash to describe the mouth and the shadow under the left cheek.

Nose: Step 6. Now, the right nostril. Indicate this with a bit of pigment that's almost pure black. (Remember that shadows almost always have some reflected light in them; so never make them black. The nostril, on the other hand, is an *accent*: almost no reflected light reaches into areas like the nostril.) Notice that the original shadow seems lighter by comparison. Notice also that some of the edges around the nostril are softened and lost where they blend with the adjacent shadows. This makes the nostril seem to be part of its surroundings, whereas a hard-edged, dark area would appear isolated and unconnected.

Nose: Step 7. To complete this exercise, add the very subtle middle values on the light side of the nose. Remember not to make them too dark, or they'll look like shadows, and the nose will "flatten out." (Compare the sketch on the right to the illustration for this step, and you'll see that the middle values in the sketch are really too dark.) Middle values describe the specific construction of the nose areas that are in the light, and they are very important and necessary in painting a finished head. However, there is a danger that if you try to make all the subtle value changes you see the result will be an overworked and tired area. So, for now, concentrate on simple lights and simple darks and put in only a minimum of necessary middle lights.

The middle values are too dark here. The nose has "flattened out," and the result looks overworked.

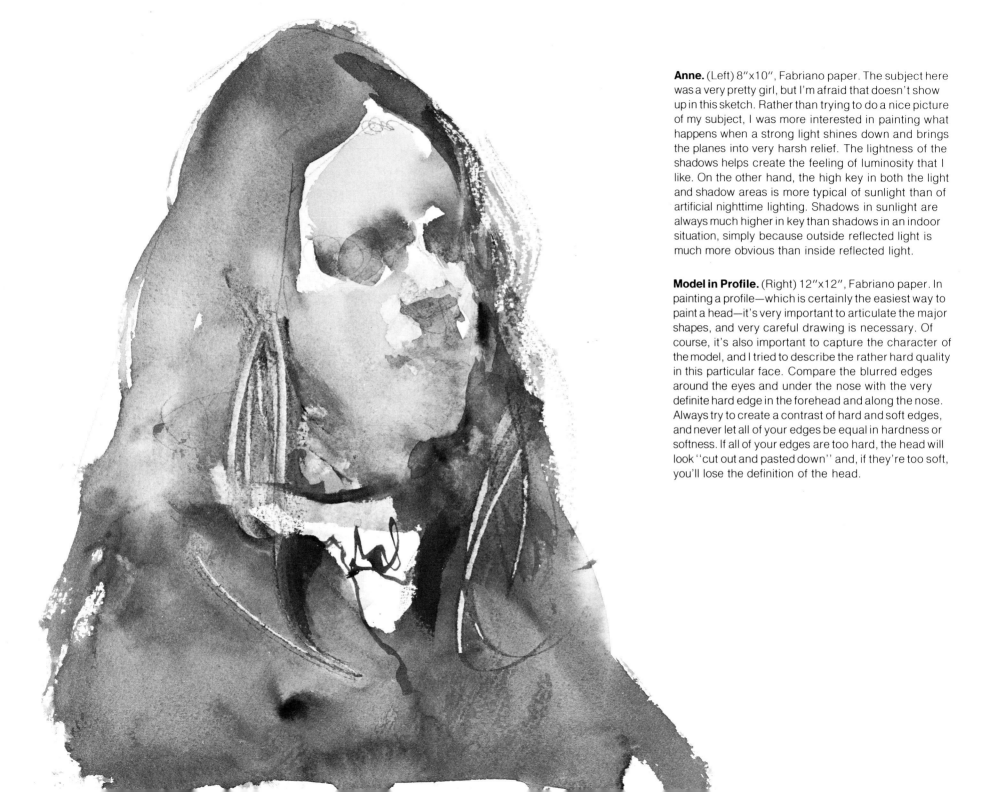

Anne. (Left) 8"x10", Fabriano paper. The subject here was a very pretty girl, but I'm afraid that doesn't show up in this sketch. Rather than trying to do a nice picture of my subject, I was more interested in painting what happens when a strong light shines down and brings the planes into very harsh relief. The lightness of the shadows helps create the feeling of luminosity that I like. On the other hand, the high key in both the light and shadow areas is more typical of sunlight than of artificial nighttime lighting. Shadows in sunlight are always much higher in key than shadows in an indoor situation, simply because outside reflected light is much more obvious than inside reflected light.

Model in Profile. (Right) 12"x12", Fabriano paper. In painting a profile—which is certainly the easiest way to paint a head—it's very important to articulate the major shapes, and very careful drawing is necessary. Of course, it's also important to capture the character of the model, and I tried to describe the rather hard quality in this particular face. Compare the blurred edges around the eyes and under the nose with the very definite hard edge in the forehead and along the nose. Always try to create a contrast of hard and soft edges, and never let all of your edges be equal in hardness or softness. If all of your edges are too hard, the head will look ''cut out and pasted down'' and, if they're too soft, you'll lose the definition of the head.

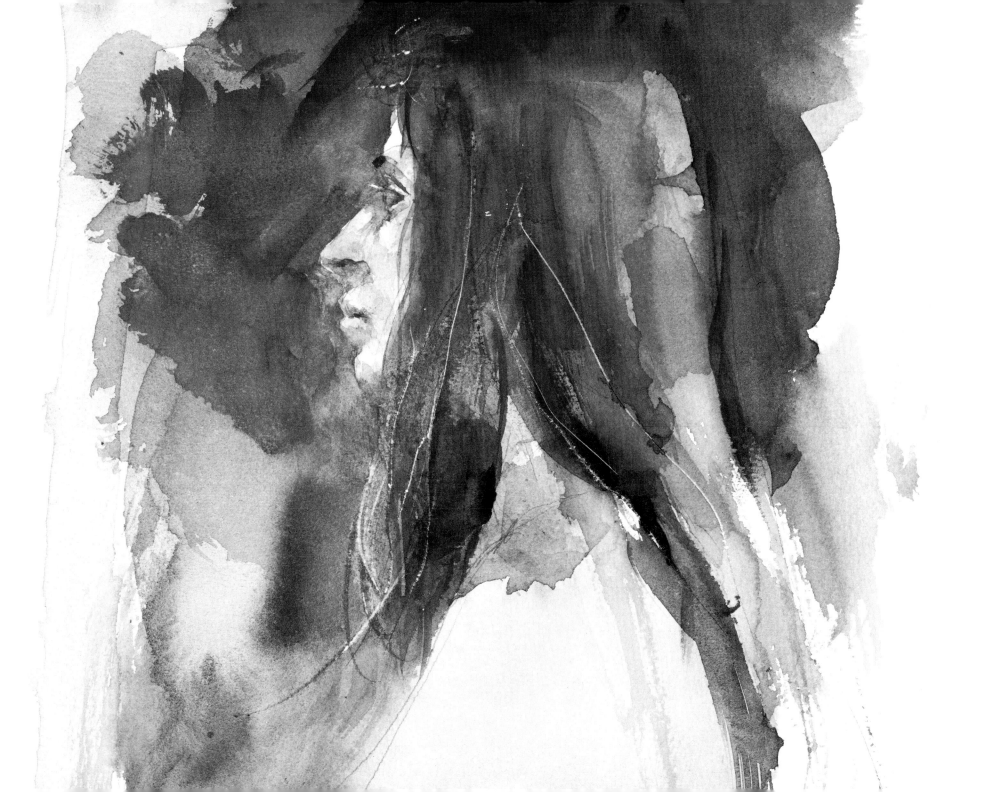

9
Mouth

Now, to the mouth. The painting problems here are the same as those of painting the other features: shape is still one of the first considerations, and the planes are important in showing the structure of the mouth. Also, be sure you have a good variety of hard and soft, or "lost and found," edges. One way to achieve a "lost" edge is to put two areas of *similar* value next to each other. The boundary between two similar values will obviously be much less noticeable than an edge between a light and a dark value.

Take a look at the illustration for Step 6, and I think you'll see what I mean. In the upper lip, we have a fairly dark value, and above it we have much lighter skin tones. Compare this fairly large value contrast or "found" edge, with the contrast between the lower lip and the skin tone below it. The *lighter* lower lip is very close in value to the skin tones next to it, and a "lost" edge or boundary is created between the two areas.

In Step 6, as you describe the area of the mouth around the dental arch of the teeth, try to give the lips and the entire mouth a feeling of roundness and form. Always remember that the line of the teeth produce a *rounded* form and that the lips must indicate this by appearing to go *around* it. The sketch at the right illustrates this point.

When you mix your washes for this exercise, remember that there is no harm in making your shadow values fairly dark. As you've seen, washes dry lighter, and, when you draw shadow areas out into light areas to make middle values, you automatically lighten the shadow.

This time, the light source is somewhere above the model. This means that you'll have shadows on your bottom planes, middle lights on your front planes, and light areas on your top planes.

Your materials remain the same: your Number 8 watercolor brush, a tube of ivory black (or Payne's gray), a water jar and clean water, pushpins and drawing board, palette, and watercolor paper.

The dental arch, or line of the teeth, is a rounded form, and the structure of the entire mouth should indicate this roundness.

Mouth: Step 1. Sketch in the mouth. We're doing more or less a front view here, and I've tried to draw an "average mouth." (Naturally, there is no such thing!) Pay particular attention to shape. Never assume you *know* the shape of the mouth or of any other feature. Come to the drawing board with a clear mind and an observant eye. Always ask yourself: how does the upper lip compare to the lower lip? Is it thinner or fatter? See how much curvature there is to the upper lip. As a general rule, the upper lip is a much more involved shape than the lower lip.

Mouth: Step 2. Now comes your first light wash. Mix a wash just as you've done before, and cover the entire mouth area and some of the surrounding areas, too. I've left a small section of untouched paper on the lower lip to indicate a possible highlight. You won't always have highlights, but, when you do, make sure they're not too big! This one seems too big, so I'll make it smaller as we go along.

Mouth: Step 3. Now for your shadow shapes. On your palette, mix up a fairly dark wash—better too dark at this stage than too light. After loading your brush, start at either corner of the mouth. Usually, there is a crease in the skin at the mouth corner, so start your stroke off wider here and then narrow it immediately at the beginning of the lips (this depends, of course, on the shape of the particular mouth you're painting). Make the stroke wider again as you approach the middle of the mouth. As you can see, I've stopped my stroke short of the center of the upper lip and repeated the procedure on the other side, leaving an untouched middle section to indicate roundness around the dental arch.

Mouth: Step 4. Rinse your brush and give it a good shake. Working quickly (you don't want the shadow wash you did in Step 3 to dry!), connect the two sides of the mouth at the middle, allowing the shadow to flow into the area you left untouched in Step 3. Notice that the middle area is still lighter than the two sides. Notice also that the two sides have become lighter because their washes have been drawn out into the light. Next, draw your shadow down into the lower lip from either corner of the mouth, leaving the middle section untouched.

Mouth: Step 5. Now, draw the values on either side of the lower lip into the middle area, repeating the process you used for the upper lip. Notice that I've allowed some of the darker areas of the lips to flow out into surrounding skin areas. (Never allow the mouth to appear isolated and unconnected to its surroundings.) One of these soft edges occurs under the lower lip, and is the beginning indication of a bottom plane under the lower lip.

Mouth: Step 6. Now, the final touches. The main thing to do here is restate areas that need emphasis and darkening. To darken the upper lip, repeat more or less the procedures you used in Steps 3 and 4. On the right side, I've allowed some of the dark upper lip shadow to travel down into the lower lip, to avoid leaving a hard, continuous division between the upper and lower lips. Remember to keep the feeling of connection and interrelationship between areas by using ''lost'' and ''found'' edges. The hard division between the lips in the middle area is lost as you soften the edges and you can make the left side even more indistinct than the right side. If you make an area *too* vague, always wait for it to dry, or almost dry, and then add a final touch of darker value to the edge.

Cast Shadow. (Right) 10″x10″, Fabriano paper. In this overhead lighting situation, I generalized the cast shadow created by the head. As a general rule, you should be sure that cast shadows express the particular form on which they lie. Here, however, there is such specific form in the face that the generalized cast shadow seems to work. Notice that I carefully articulated the planes of the face, although I used only one value in the shadows. You can see that I was very careful to capture the quality of this particular model's face.

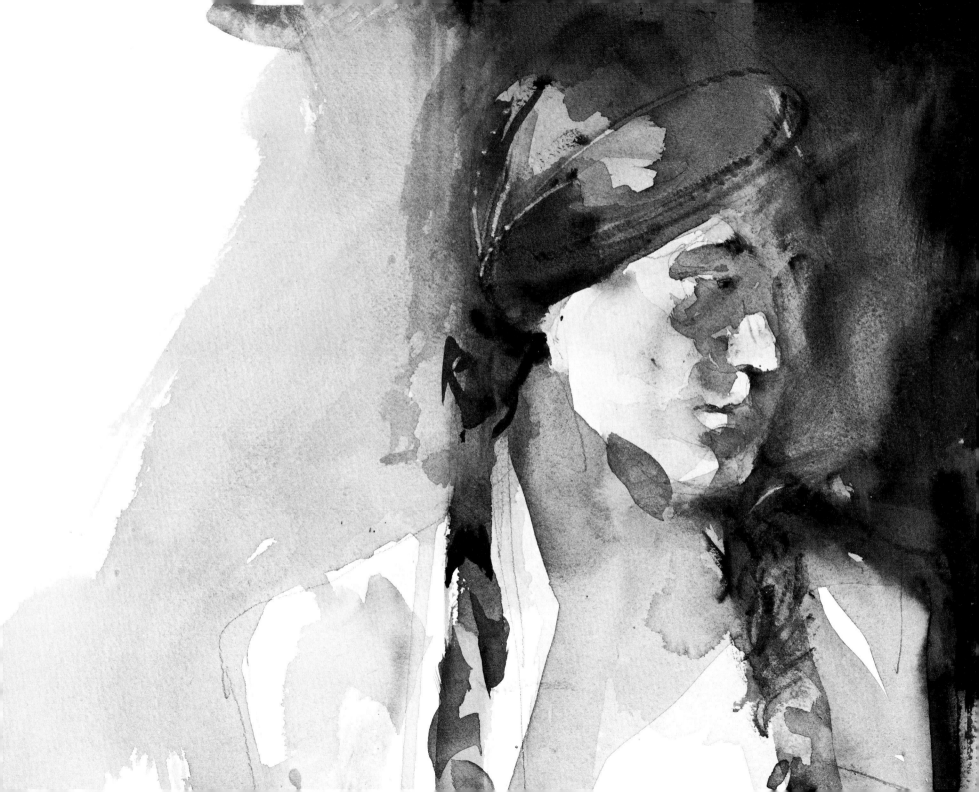

10
Ears

The ears are very important features and should never be carelessly drawn or painted. A poorly drawn ear is often the mark of an amateur. You should take just as many pains with the ear's shape and construction as you take with any other feature. Always observe carefully, and try to capture, the particular construction of this rather complicated form.

One common mistake is to make the inner fold at the top of the ear the same shape as the top of the outer boundary. I've drawn the sketch below to illustrate this error. In the correctly drawn ear on the *right*, notice that the top of the inner fold is quite straight, while the outer boundary is curved. This is a *general* rule, although you might sometimes be hard-pressed to see a difference between these two shapes. Even if the two shapes look exactly the same, I'd *vary them*, since I don't feel there ever should be two parallel lines, equal curves, or similar angles, on the human form.

It's probably safe to say that nothing in nature is exactly symmetrical. This is a very important point to remember. When you draw a curve, look for an angle to contrast with it; when you have a straight line, look for a curve or an angle for contrast.

For this demonstration, we'll do the ear in side view, so we can see as much of its form as possible. We'll assume that the light is coming from the front and also from slightly behind the head. When you're painting a particular ear, study the outer contours and the inner areas until you see their exact structure.

In this exercise, hard and soft edges will be vital in showing the construction of the ear, and I'll keep mentioning them, because I want you to see all they do for the ear you paint! Remember, too, that your wash has to be damp when you soften an edge, so always soften edges as you go along, rather than completing the whole area and *then* softening.

In Step 6, I'll use two techniques: *wet-in-wet* and *dry-brush*. Wet-in-wet is extremely useful in making soft, lost edges. It consists of adding a second, *wet* wash to the wash that is already on your paper, *before* the first wash is dry. When you use wet-in-wet, be sure that neither wash is too wet, or you'll destroy the effect. When drybrush is indicated, simply load your brush straight from the paint tube, mixing it with little or no water, and apply your *dry* strokes to plain paper or *dried* washes.

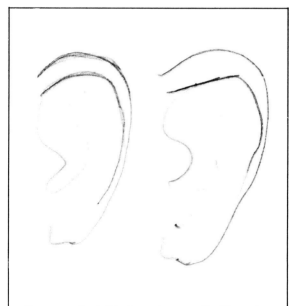

The ear on the left is drawn incorrectly. The outer boundary at the top of the ear should never be the same shape as the inner fold. In the correctly drawn ear at the right, the inner fold is straight, while the outer boundary is curved.

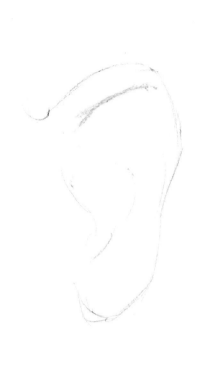

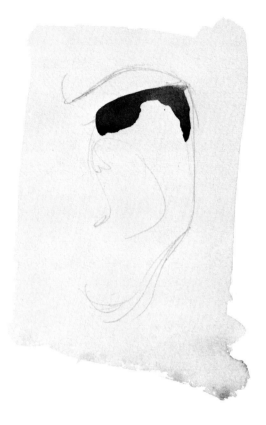

Ears: Step 1. Look first at the outer shape of the ear. Notice that the top is a simple curve that becomes straighter as it starts down at the back. Some ears can be described by a simple curve along the back edges, others by almost straight lines, and still others by a much more complicated system of curves and angles (like the one we're drawing here). Sketch in the inner shapes very lightly. You want only a light "blueprint" as a guide when you block in the inner shadow shapes.

Ears: Step 2. Lay a light wash over your drawing and allow it to dry.

Ears: Step 3. Begin blocking in the inner shadow shape under the fold that runs along the top of the ear. There is usually more distance between the top fold and the inside of the ear near the skull, so start with a fat shadow shape on the left, and narrow it as your stroke reaches this large inner space. (This large inner form doesn't always go directly up to the top of the ear flap as I've indicated here, but there is always some form which makes up the inner ear area.) Back to your shadow shape. Notice that it widens then gradually thins again as it starts down the right side of the ear.

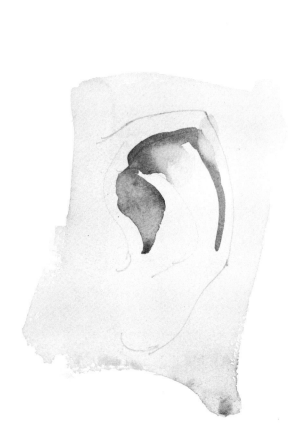

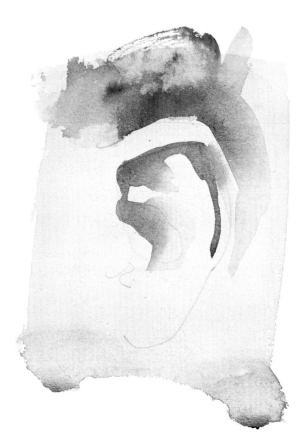

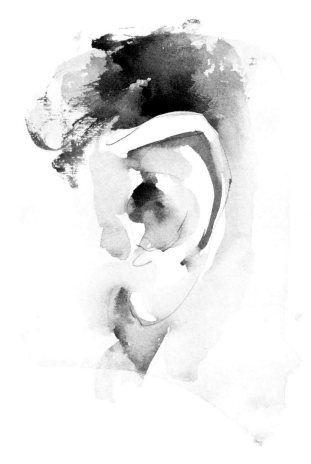

Ears: Step 4. Now for some edge-softening. Rinse out your brush, give it a good shake, and soften the lower, inside edge of the large shadow shape before it narrows. The soft edge describes the crevice in the inner ear form. I've also softened the outer edge of the shadow strip on the right, after painting this strip almost three-fourths of the way down the ear. Now back to the front of the ear. With your shadow wash, indicate a very narrow spot on the left, under the original shadow shape, then the very large indentation that is typical of almost all ears. In this case, I've shown the indentation as a ''teardrop'' shape.

Ears: Step 5. More softening takes place as you use your damp brush to lighten and soften the inner edge of the dark teardrop shape. Darken the area above the ear to indicate hair and to create some background that will offset the lighter sections of the ear. It doesn't matter if the softened area on the right side of the ear is still wet and you get a soft, ''lost,'' edge between this shadow section and the background. See how the hard and soft edges, both within the ear and around the outside, help to show the particular construction on the right side of the ear.

Ears: Step 6. Below the lobe, which is quite light, add the surrounding dark tones. Don't work into light or fairly light areas, and don't add too much detail, or you'll destroy the feeling of your light area. *After* you've established your surrounding darks, let some of the darker values flow out into the light bottom lobe as subtle middle values. Blot these middle values so they don't become too dark or too large. Now use your darkest dark to indicate the center section of the ear, using wet-in-wet to keep the edges soft. Finally, add some drybrush for hair, and a middle value along the head, to contrast with the light ''flap'' below and along the front edge of the ear.

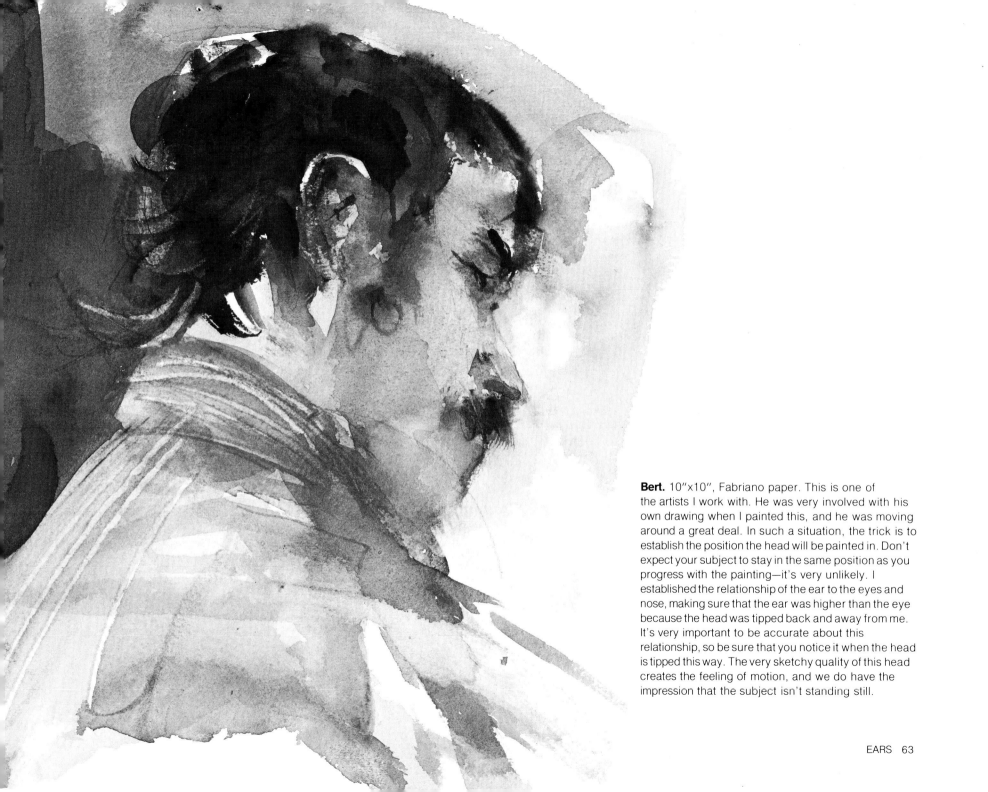

Bert. 10"x10", Fabriano paper. This is one of the artists I work with. He was very involved with his own drawing when I painted this, and he was moving around a great deal. In such a situation, the trick is to establish the position the head will be painted in. Don't expect your subject to stay in the same position as you progress with the painting—it's very unlikely. I established the relationship of the ear to the eyes and nose, making sure that the ear was higher than the eye because the head was tipped back and away from me. It's very important to be accurate about this relationship, so be sure that you notice it when the head is tipped this way. The very sketchy quality of this head creates the feeling of motion, and we do have the impression that the subject isn't standing still.

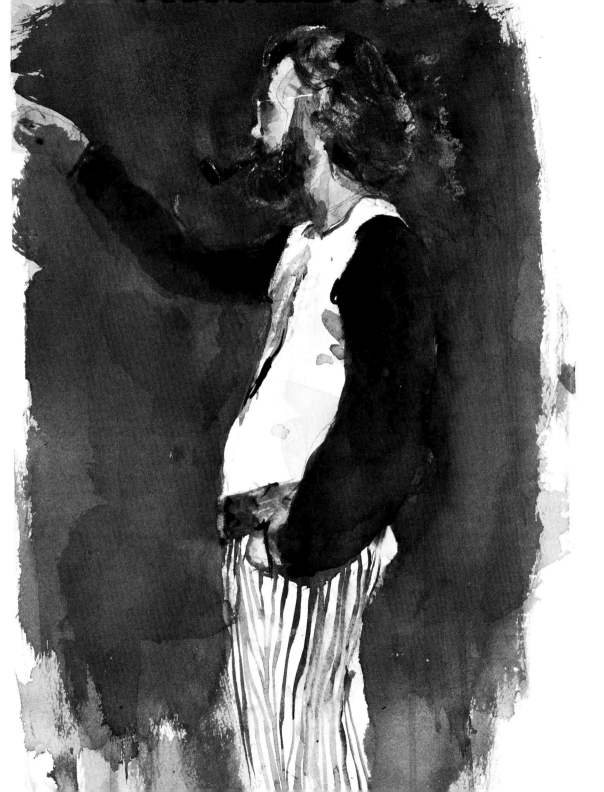

Bob. (left) 8"x14", Fabriano paper. This is a painting of a friend of mine who was working at his easel at the time. He's quite proud of his build, which is really excellent, so it was fun to catch him in this rather unheroic pose. Notice how I painted the stripes in the trousers. I used different values and made some stripes darker than others. I also blotted some of the stripes to relieve the monotony. I used the stripes to help describe the form of the legs. Notice the darker value on the back of the upper leg.

Light and Shadow. (right) 10"x14", Fabriano paper. This model was sitting against a white wall. After I washed in my lights, I started blocking in the shadows in the face and then went on to the hair. I articulated the form in the face quite carefully, and I really tried to capture a good feeling of the model's characteristic features. As I blocked in the shadows on the figure, I allowed them to bleed out into the background to create the same colors and values in both areas. After allowing these areas to set for a few moments, I added a very small dark area wet-in-wet to separate the neck from the background. A dark separation like this should be very soft and unimportant, so don't wait too long to add it. Be sure you get a good blur in this kind of shadow area. Remember that details in shadow should always be much less definite and much less distinct than details in light.

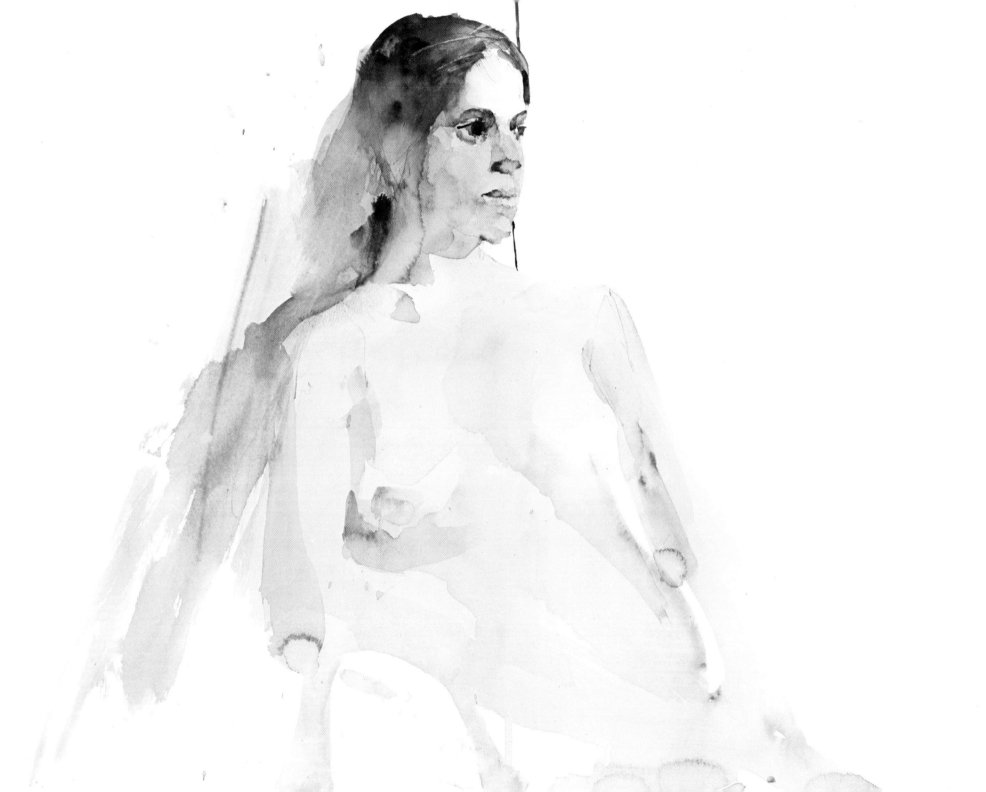

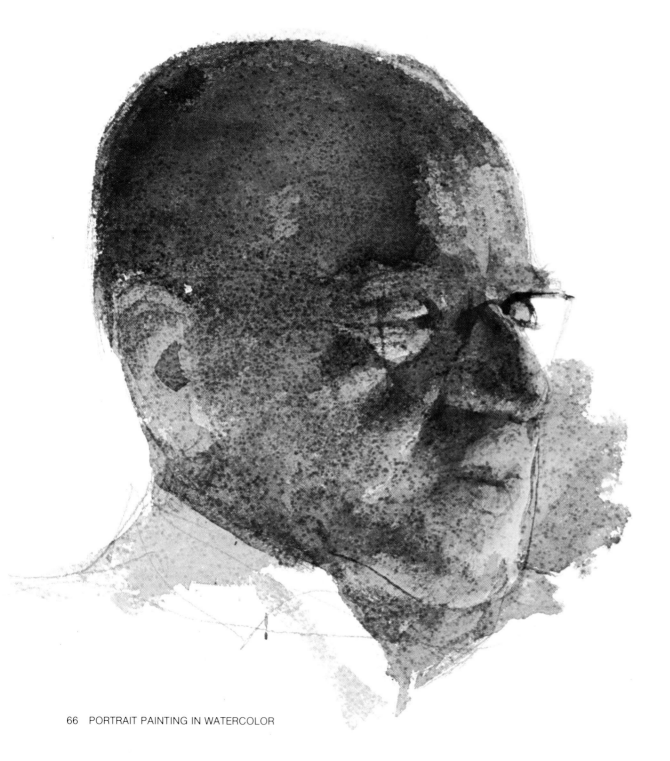

Old Man. (left) 8″x10″, Fabriano paper. This head had a very interesting pattern, with the light working across the nose and catching the right eye. The right eye is actually the lightest section in the head. I usually keep the light areas that are surrounded by shadow darker than light areas that are in the main light section of a head; but I'm always willing to break a rule to help a painting. This time, by making the light area within the shadow the lightest section of this painting, I made this area the center of interest.

Martini. (right) 8″x10″, Fabriano paper. I did this painting from a pencil drawing that I'd made on the spot. I didn't worry about my colors here. I was more interested in capturing the feeling of this rather stark and lonely figure emerging from a murky background. Although some artists do very involved paintings from sketches, I don't often work from them because I don't feel sketches give me enough information to do a satisfactory painting. But so much of this picture was understated and unsaid that the sketch certainly made an adequate reference.

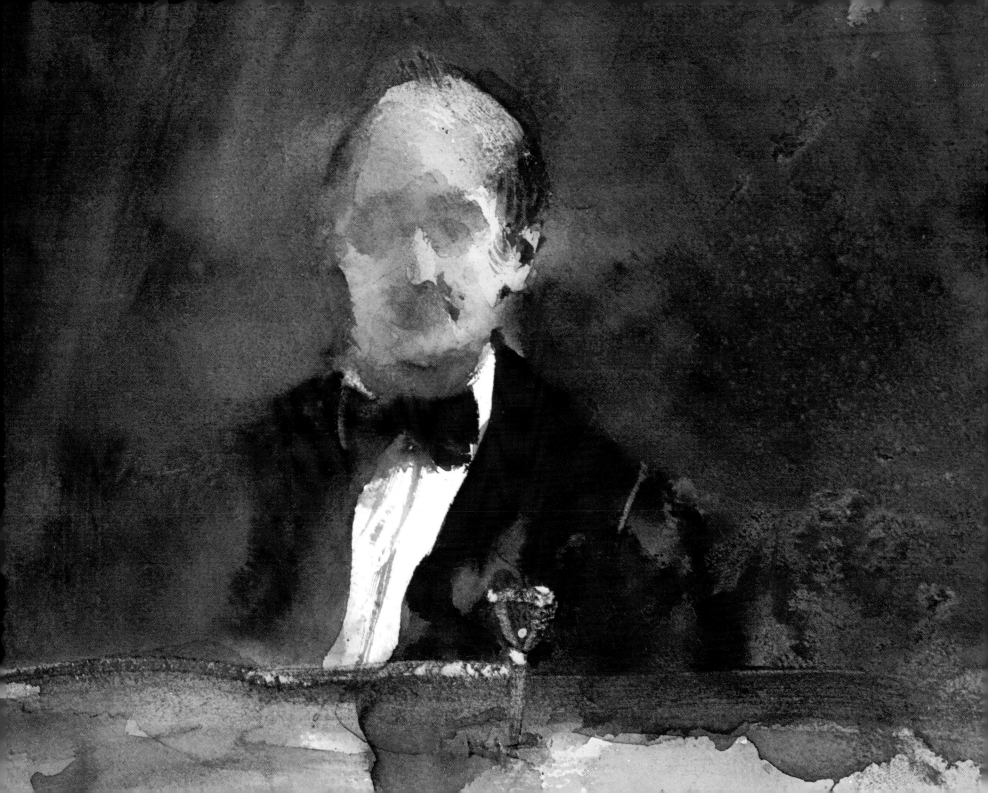

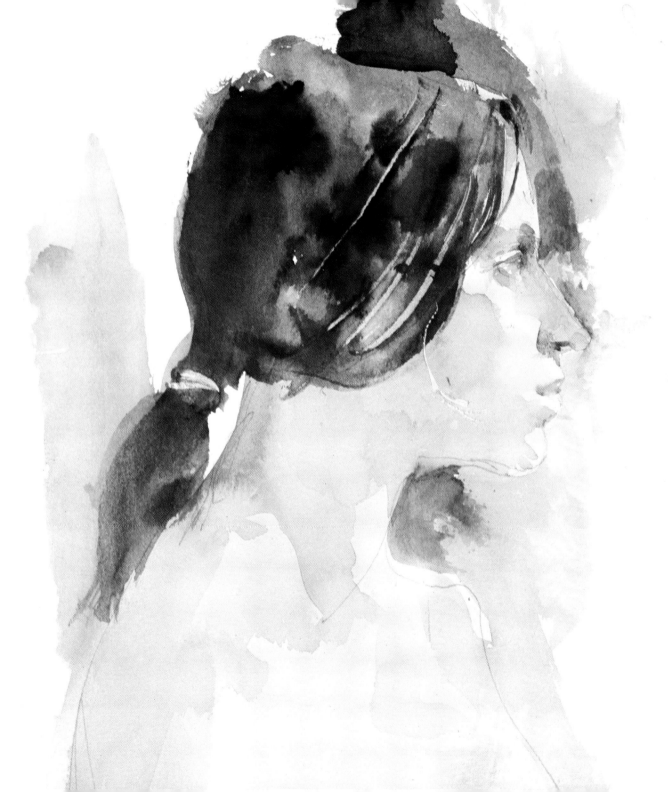

Blonde Model. (left) 8''x14'', Fabriano paper. Here, the front of the face is in light and, beyond the light-struck areas of the face, there is a much darker background. I usually paint the background very dark, but here I used very subtle values adjacent to the light-struck sections of the face to bring out those light areas. I think it's a very good idea to paint what you see, but you should also be willing to make any changes that might strengthen your picture.

Resting. (right) 12''x14'', Bristol paper. This painting doesn't seem particularly successful to me. I think the problem was that it's difficult to paint a head that's not upright. As with a reclining figure, the proportions and forms of the head seem to change when it's held at such an angle. Some areas flatten out while others lengthen.

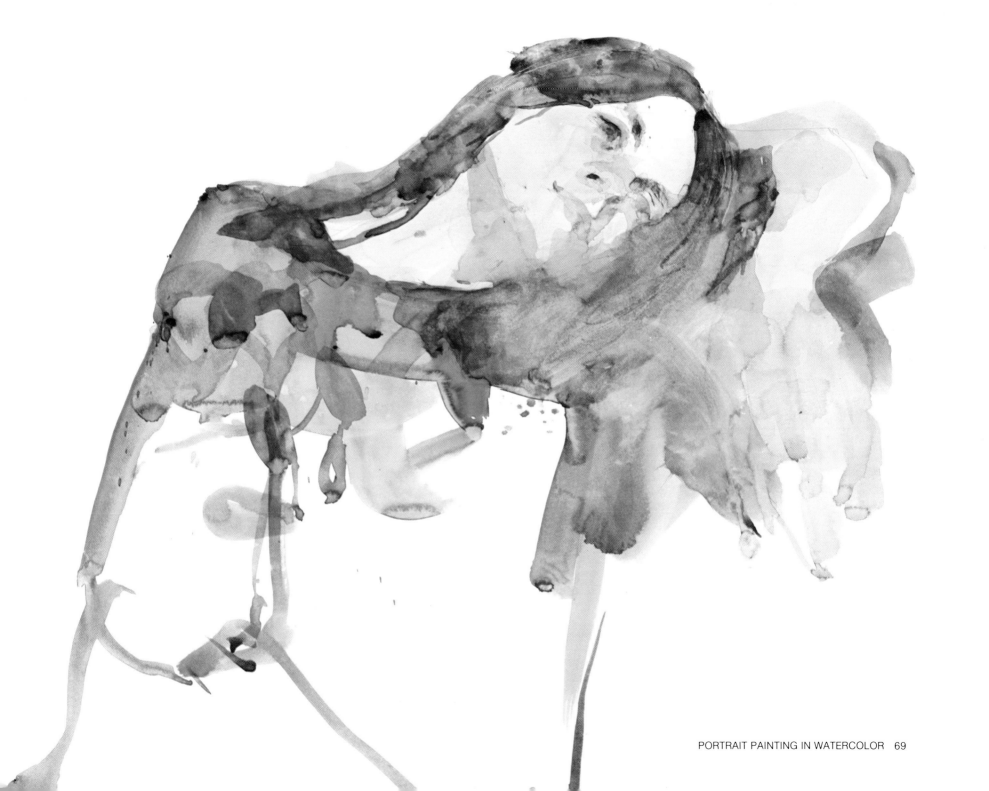

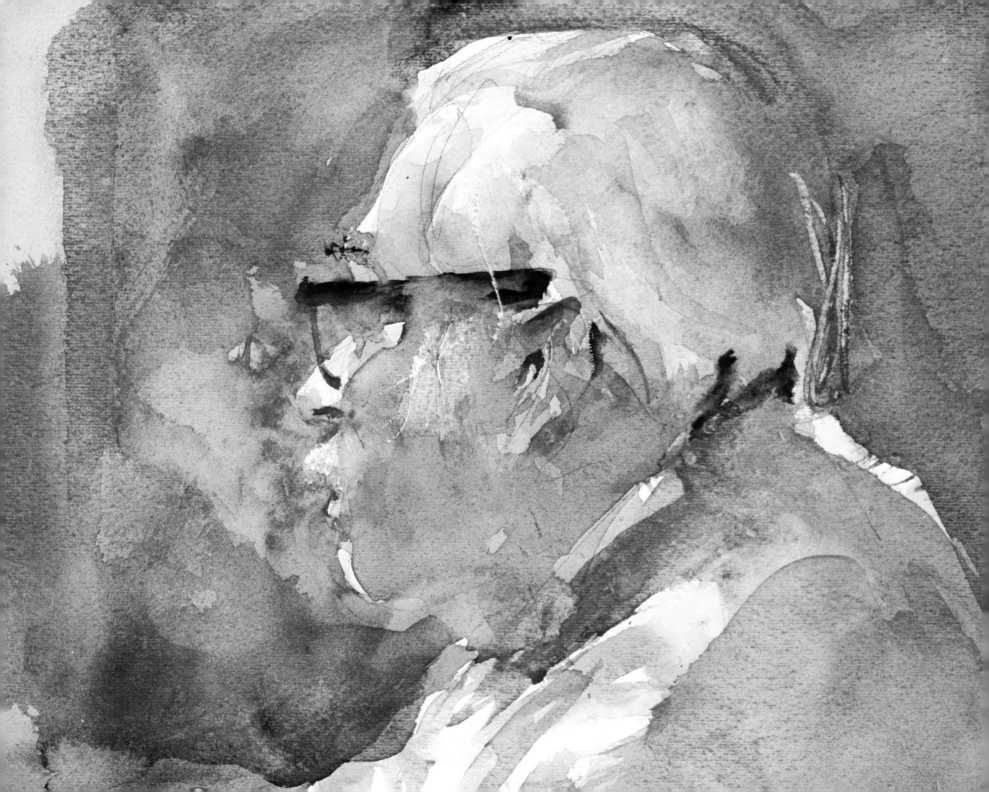

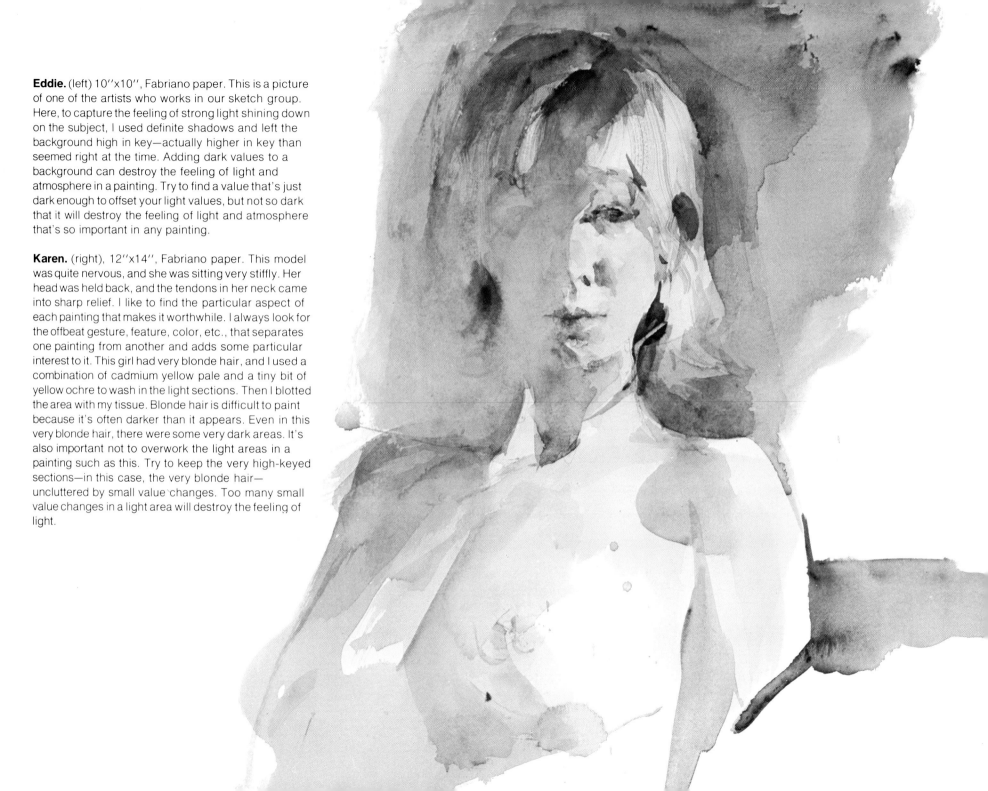

Eddie. (left) 10"x10", Fabriano paper. This is a picture of one of the artists who works in our sketch group. Here, to capture the feeling of strong light shining down on the subject, I used definite shadows and left the background high in key—actually higher in key than seemed right at the time. Adding dark values to a background can destroy the feeling of light and atmosphere in a painting. Try to find a value that's just dark enough to offset your light values, but not so dark that it will destroy the feeling of light and atmosphere that's so important in any painting.

Karen. (right), 12"x14", Fabriano paper. This model was quite nervous, and she was sitting very stiffly. Her head was held back, and the tendons in her neck came into sharp relief. I like to find the particular aspect of each painting that makes it worthwhile. I always look for the offbeat gesture, feature, color, etc., that separates one painting from another and adds some particular interest to it. This girl had very blonde hair, and I used a combination of cadmium yellow pale and a tiny bit of yellow ochre to wash in the light sections. Then I blotted the area with my tissue. Blonde hair is difficult to paint because it's often darker than it appears. Even in this very blonde hair, there were some very dark areas. It's also important not to overwork the light areas in a painting such as this. Try to keep the very high-keyed sections—in this case, the very blonde hair—uncluttered by small value changes. Too many small value changes in a light area will destroy the feeling of light.

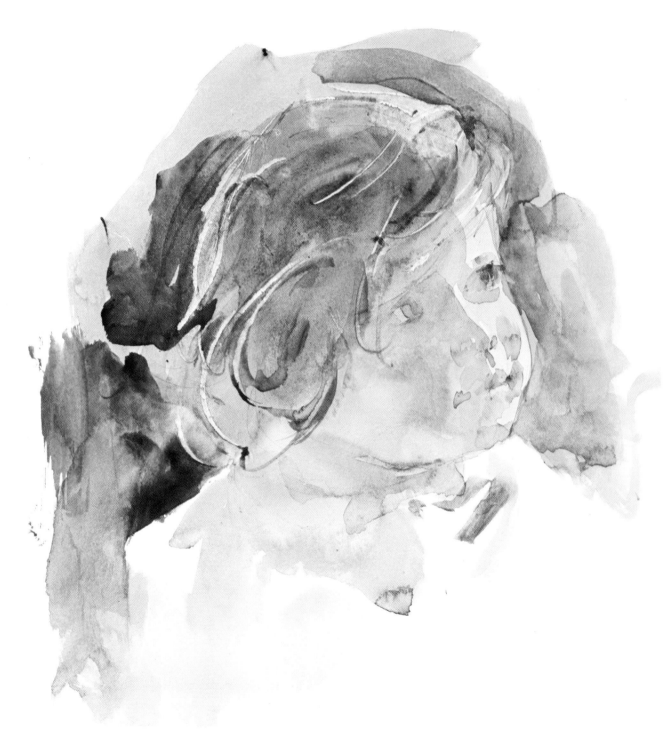

Sarah. (left) 10″x10″, Bristol paper. Painting children is extremely difficult for the obvious reason—they won't stay still. Because of this, I think watercolor is an excellent medium to use in painting children. It allows you to make statements much more directly and quickly than oil does. Of course, this is a generalization, and some artists who are very adept at sketching in oil will probably disagree with me. It's also important—and helpful—to make a good drawing first, as well as to accept the fact that your model probably won't return to exactly the same position when you get to the painting stage. If your drawing is good enough, and you study your subject well, you can certainly do an acceptable painting even when the subject isn't absolutely stationary. For this painting, I used the television set to keep my daughter as still as possible. Although a child's expression may be rather vacant when you use this trick, it's a good way to keep your subject in one place.

Gabrielle. (right), 10″x14″, Fabriano paper. This model was in a more difficult lighting situation than most of those in this book. Notice the very light strip along the far side of the face. This is the main light area and white paper—or a very light preliminary wash—can be used to describe such a light section. The reflected light that we see in the side of the head facing us created a problem. You should always show the difference between reflected light and your main light: the reflected light should never be as light as your main light. In this painting, I first covered the whole head with a very light wash and allowed it to dry. Next, leaving the strip down the far side of the head untouched, I blocked in the rest of the head with a fairly light shadow value. Again, I allowed the wash to dry and finally, I added my darkest darks. As a rule, I try to avoid this "shadow within shadow" situation. Shadows should be simple in value—that is, there should be as few value changes as possible in shadow areas. In this case, however, I had no choice, and the shadow side of the head is fairly involved.

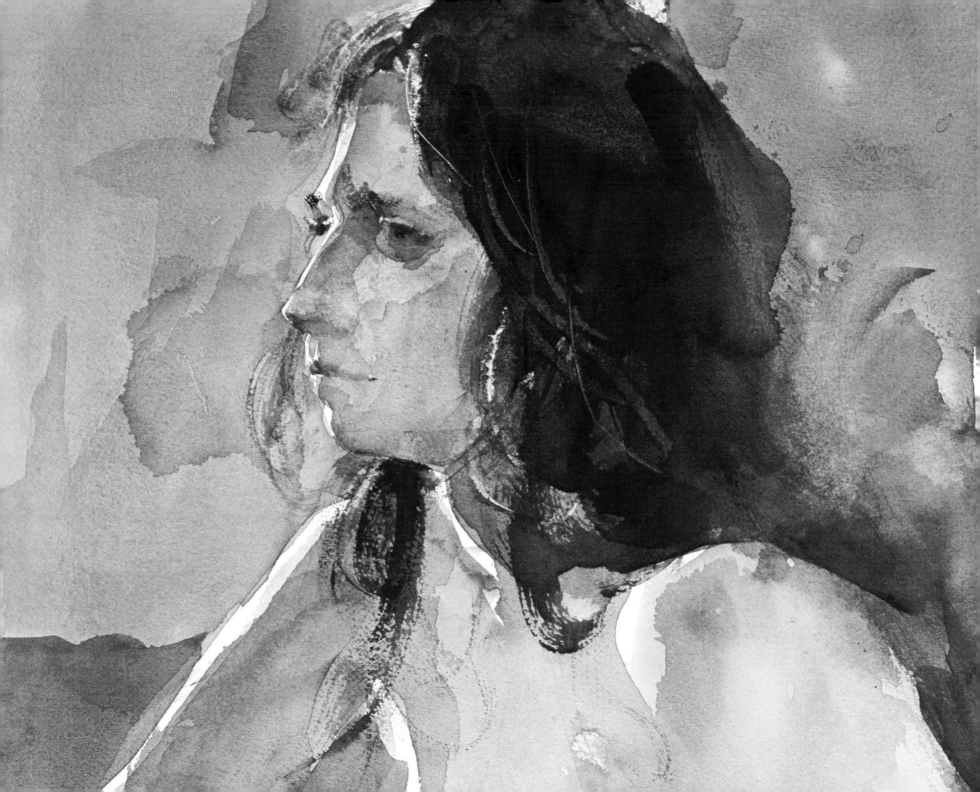

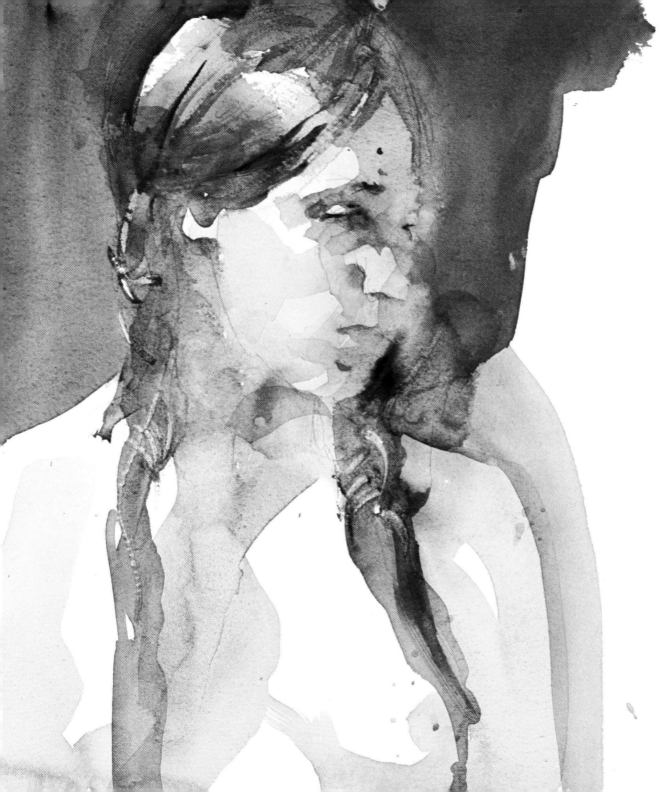

Model in Red Background. (left), 8''x10'', Fabriano paper. I've always had trouble painting red backgrounds, probably because I prefer the cooler colors. The shadow on the face bled more than it should have because I used too much water in the shadow wash. You can see this in the area where the nose meets the background. The balloon was created because there was too much water in the shadow wash under the nose, and the water spread out into the background. Usually I'd restate the background, but I liked the glossed edge here. Notice, however, that I did restate the darker hair near the mouth and that I left definite boundaries in some areas while I softened other boundaries. It's not necessary to state an entire boundary—you can merely articulate certain sections of it. It's very important not to separate each area of a painting from the adjacent areas. Of course, some separation is important but, when areas are similar in value, it's a good idea to soften the division between them.

Violinist. (right) 10''x12'', Fabriano paper. This was done from a photograph of a boy intent on playing his violin. I was mainly interested in the pattern that the light made on his white shirt. I also tried to catch the raking light striking the violin and the small area around the ear. There was also a suggestion of light on the nose. To me, such a painting is an interesting study of the effect of light on a subject, and the business of catching this effect is one of the most intriguing parts of painting.

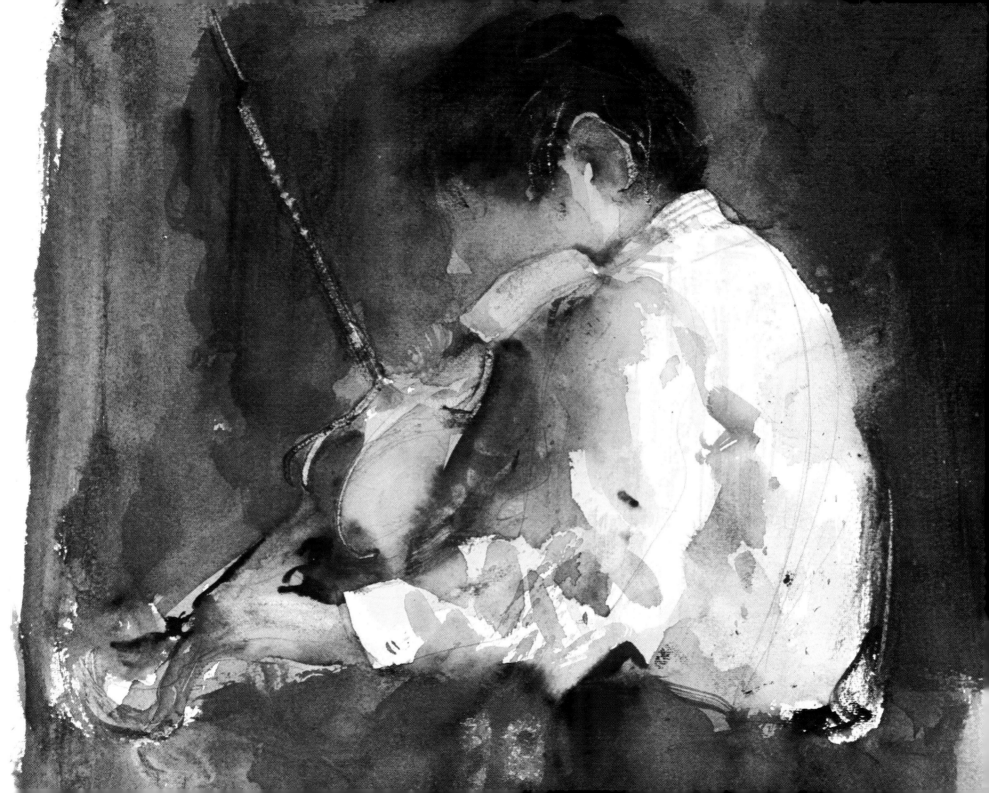

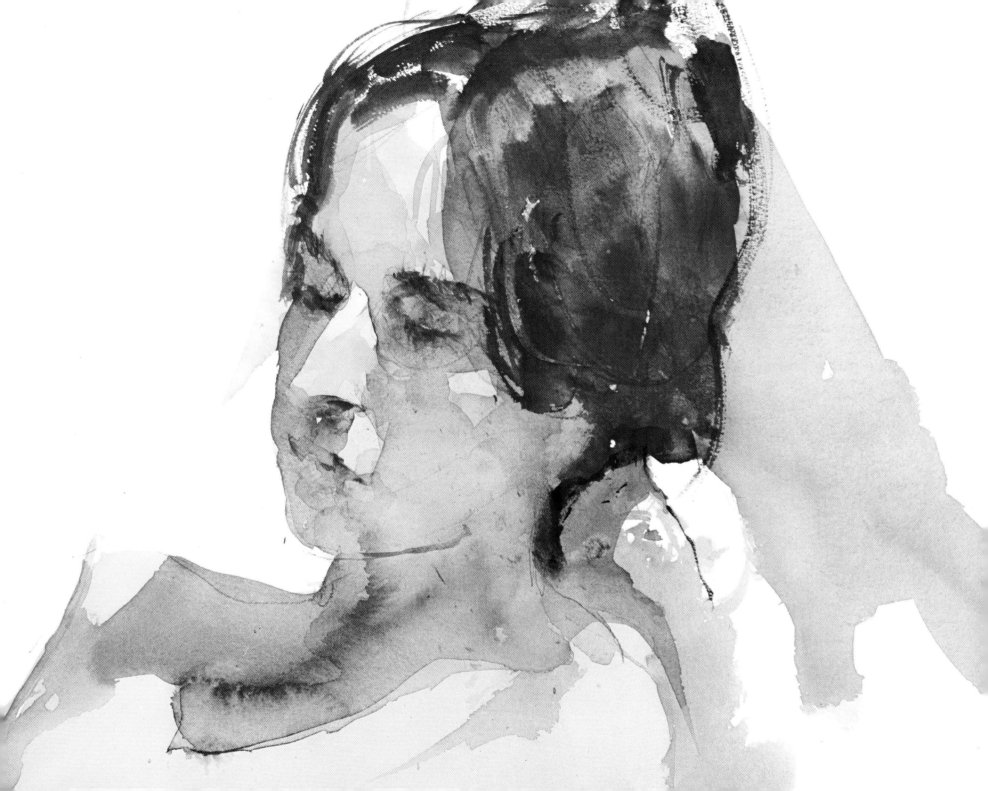

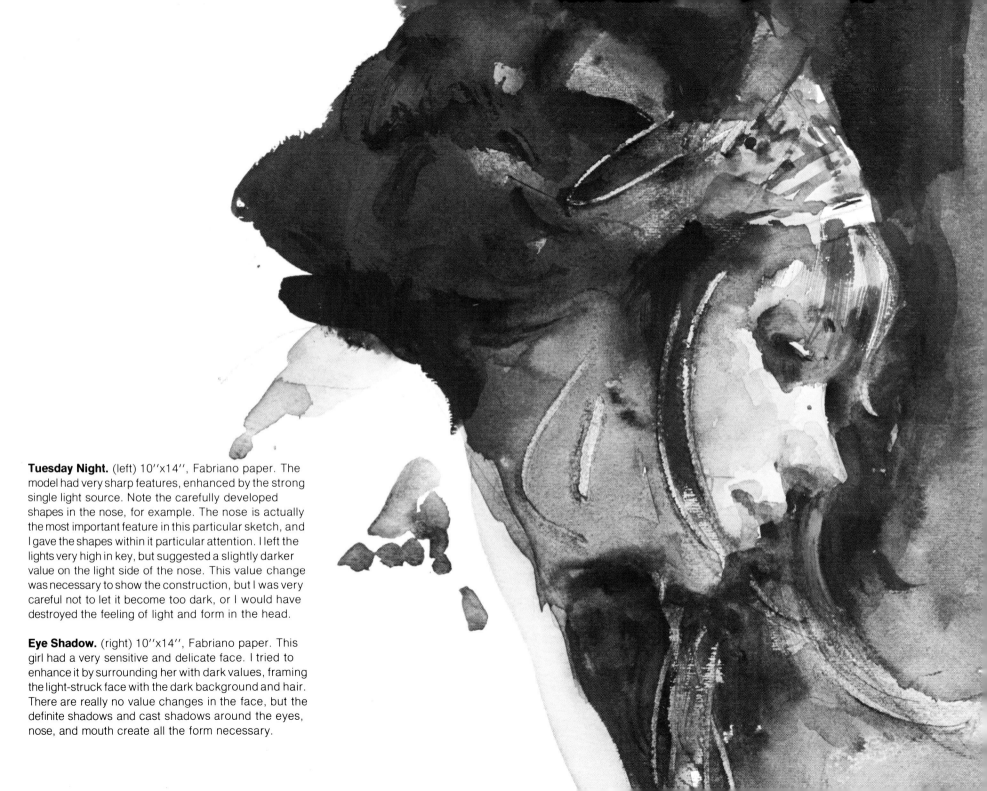

Tuesday Night. (left) 10″x14″, Fabriano paper. The model had very sharp features, enhanced by the strong single light source. Note the carefully developed shapes in the nose, for example. The nose is actually the most important feature in this particular sketch, and I gave the shapes within it particular attention. I left the lights very high in key, but suggested a slightly darker value on the light side of the nose. This value change was necessary to show the construction, but I was very careful not to let it become too dark, or I would have destroyed the feeling of light and form in the head.

Eye Shadow. (right) 10″x14″, Fabriano paper. This girl had a very sensitive and delicate face. I tried to enhance it by surrounding her with dark values, framing the light-struck face with the dark background and hair. There are really no value changes in the face, but the definite shadows and cast shadows around the eyes, nose, and mouth create all the form necessary.

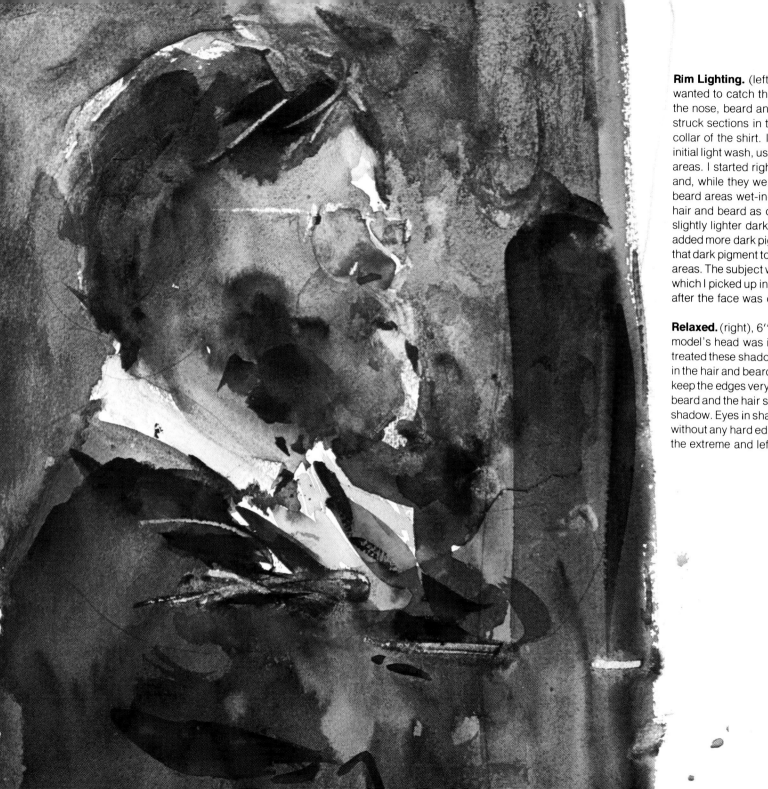

Rim Lighting. (left) 8″x14″, Fabriano paper. Here, I wanted to catch the lights flicking across the edge of the nose, beard and forehead. Notice also the light-struck sections in the top of the head and around the collar of the shirt. I did this painting without my usual initial light wash, using white paper for my light-struck areas. I started right off with my shadows in the face and, while they were still wet, I added the hair and beard areas wet-in-wet. Notice that I didn't paint the hair and beard as one solid dark. I started off with slightly lighter darks in the hair and beard and then added more dark pigment in certain sections, allowing that dark pigment to blend in with the surrounding wet areas. The subject was wearing steel-rimmed glasses, which I picked up in certain areas with my razor blade after the face was dry.

Relaxed. (right), 6″x10″, Fabriano paper. Most of this model's head was in shadow and, as you can see, I treated these shadows very broadly. I used wet-in-wet in the hair and beard where they recede into shadow to keep the edges very soft and indistinct. Notice how the beard and the hair seem to be ''lost'' as they enter the shadow. Eyes in shadow should also be very indistinct, without any hard edges or definite detail. Here, I went to the extreme and left one eye out altogether.

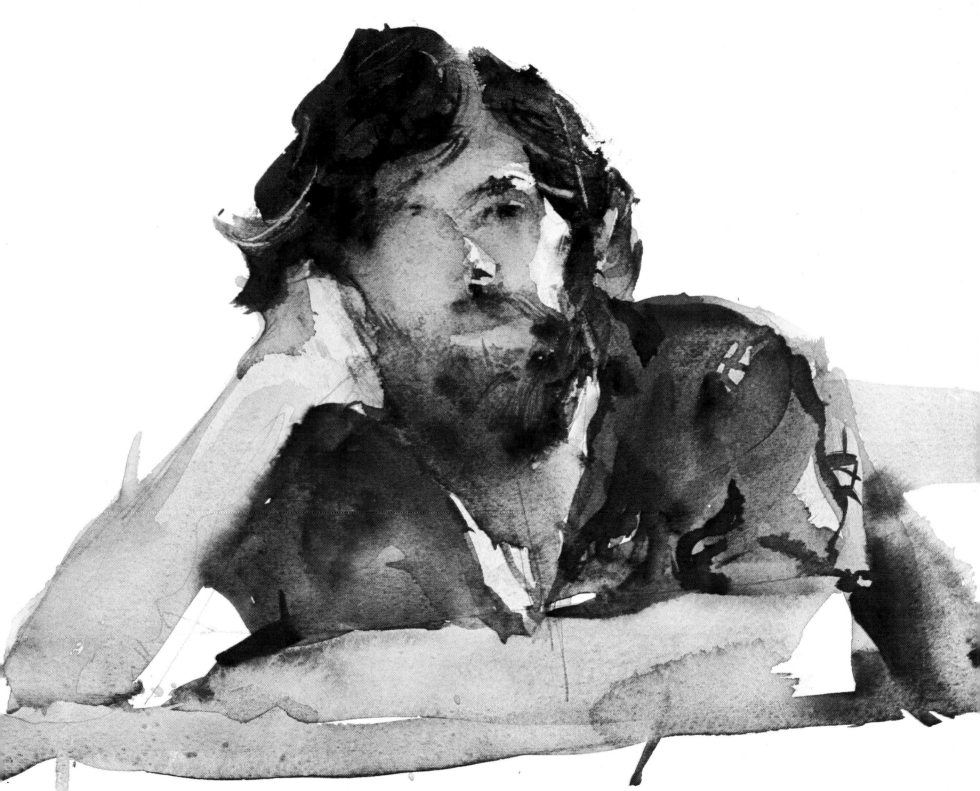

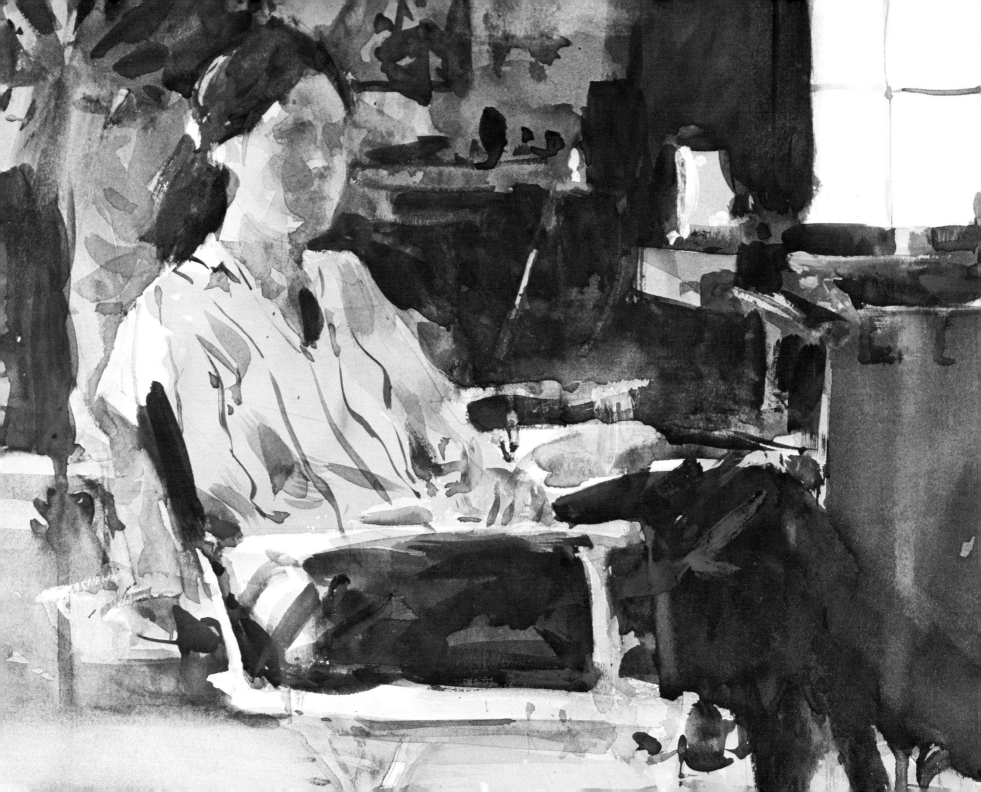

The Hair

11
Light Hair

The two tricks to painting hair successfully are *understatement* and *soft edges*. In painting hair, the desire to keep working—trying to capture the illusive texture—is always there. And there is also the difficult business of making some soft, lost edges. However, it's much better to make a broad statement, indicating only the major planes you see in the hair, and *then* to go on to the rest of the face without any further work on the hair. When the head is almost finished, you'll have a better idea of what finishing touches the hair needs. When your hair washes are dry, you can add a few judicious drybrush strokes, as well as any necessary restatement of shadows.

Remember that hair has a soft texture and that softening edges is one way to describe this texture accurately. Be particularly careful not to make a hard, precise line where the hair meets the face. A hard edge makes the hair look like a wig. You should have a subtle, irregular transition between hair and skin. This transition is easiest to make when you're painting blonde hair. It's more difficult with dark hair and light skin, but the transition must still be made as soft and subtle as possible.

In this demonstration, we'll deal specifically with painting short, light hair, but the principles we discuss will apply to any areas of hair you paint. The only technique that will change is the particular one you use to describe different hair textures: short, coarse hair needs more drybrush, while long, fine-textured hair should be handled with more overwashes and a bit less drybrush. Drybrush, however, is important in light-struck areas, as you'll see in the next demonstration.

For materials, use ivory black, a Number 8 watercolor brush, water jar and clean water, watercolor paper cut into 6" x 8" pieces, a drawing board, pushpins, and a Number 2 office pencil. We'll assume that the light is coming from the right and above, so we'll have a shadow on the left side of the face and hair.

 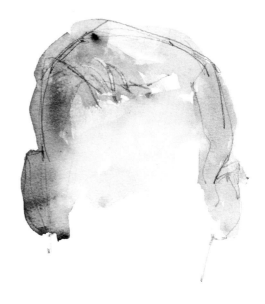

Light Hair: Step 1. Concentrate on good outside shapes as you sketch in the boundaries of the top part of the head. Draw lightly, and be ready to restate a shape without erasing if you can make it more descriptive of the hair and head. Mix up a middle wash—not as light as your usual first value—and start washing in the hair and the left side of the face. Naturally, some light areas must be left untouched, but as a general rule, remember not to separate shadow areas according to lighter and darker values in the beginning.

Light Hair: Step 2. While this wash is still wet, draw it out into the right, or light, side of the hair and face. Notice that I've left some areas of the hair untouched and that the white paper is visible. Note also the hard edge in the middle section of the hair, with soft, lost edges on either side. Where you leave white paper and hard edges naturally depends on the particular hair you're painting.

Light Hair: Step 3. Before this wash dries, scratch out some light strands with your fingernail. (In my illustration, notice that the darker, hard edge I mentioned has softened. This was unintentional, and I'll have to restate this area when the wash dries.) Don't do anything more until the whole area is dry. (If you were doing a portrait, you would now go on to work on the rest of the face and come back to the hair later.) The only thing you might do now is blot some areas that have become too dark; but remember that all of your washes will dry lighter, so don't blot too much.

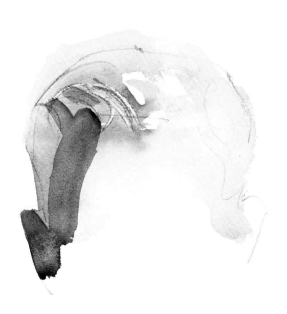

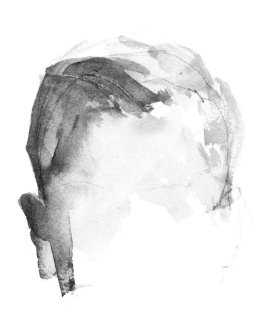

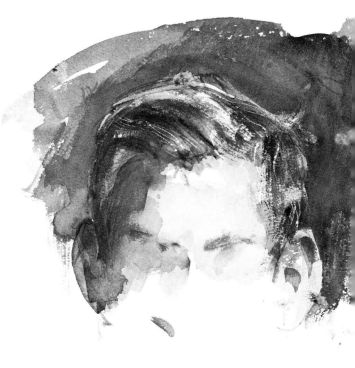

Light Hair: Step 4. When everything is dry, put in your darker darks. The blonde hair we're painting here has some areas in shadow next to the skin on the left side, so state that darker side plane of the face.

Light Hair: Step 5. Now, working quickly, allow the shadow on the side plane to merge into the hair. Nothing is precious here; if you lose the light section of the hair on the shadow side, don't worry: you can always lift it out with a tissue. Reload your brush and, working toward the right, add more darks. Leave as much white paper as possible, but, again, don't worry if you cover some of it up with your strokes. Use more and more drybrush as you work here. Blot some of the darker areas on the right: don't let this section become darker than the shadow side.

Light Hair: Step 6. Now, the final—and really the most difficult—step. The difficulty arises with that desire to "over-finish." What you need is some judicious drybrush work! You don't want the drybrush to be black, but it should be nice and dark. Leave the light areas almost untouched, with just the barest amount of drybrush work. Don't go into your shadows except to restate the darks where necessary. For this restatement, use overwash and, when this is dry, add one or two strokes of drybrush. Now add some background tone to offset the lighter hair values. While the background is still wet, scratch into it to suggest the short hair strands. You can use a razor blade, brush tip or your fingernail. Don't overdo this scratching into wet areas; too much can ruin your picture. Notice the soft edges both on the inner and the outer boundaries of the hair.

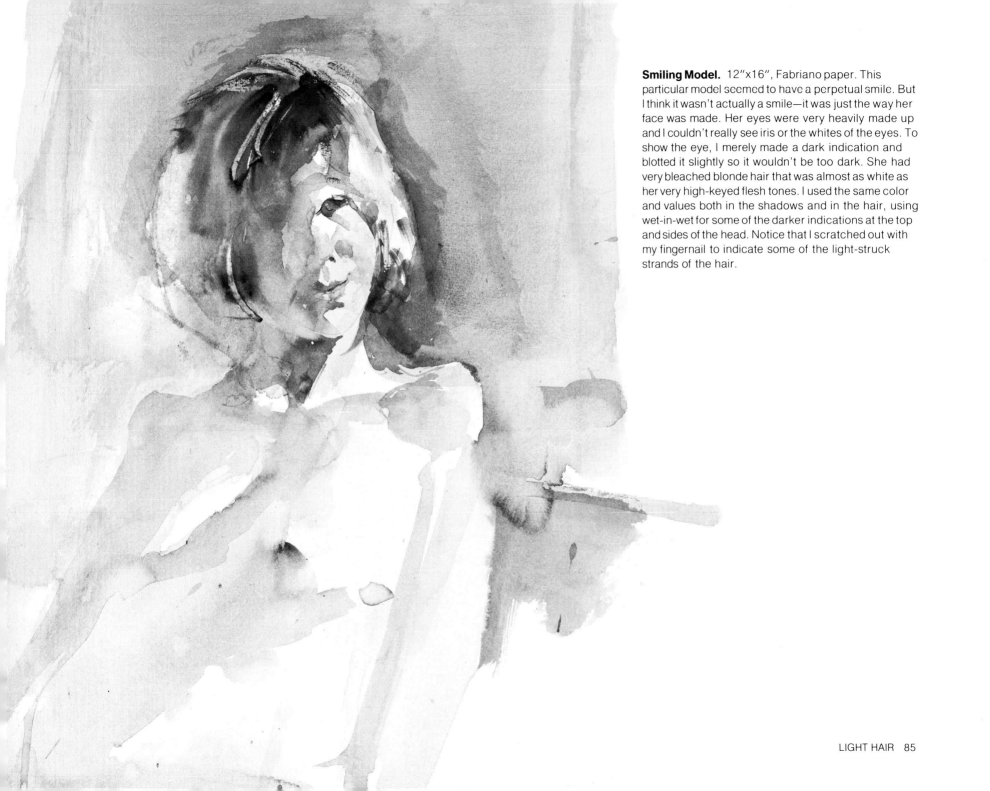

Smiling Model. 12"x16", Fabriano paper. This particular model seemed to have a perpetual smile. But I think it wasn't actually a smile—it was just the way her face was made. Her eyes were very heavily made up and I couldn't really see iris or the whites of the eyes. To show the eye, I merely made a dark indication and blotted it slightly so it wouldn't be too dark. She had very bleached blonde hair that was almost as white as her very high-keyed flesh tones. I used the same color and values both in the shadows and in the hair, using wet-in-wet for some of the darker indications at the top and sides of the head. Notice that I scratched out with my fingernail to indicate some of the light-struck strands of the hair.

12
Dark Hair

Now, for dark hair. As I mentioned in the previous demonstration, the principles of painting hair are the same, no matter what the color, value, or texture. This time, you'll be painting long, dark hair, and you should try to indicate a fine, smooth texture. In the illustration for Step 4, notice the soft edges around the hairline, where the hair meets the skin. I'd rather see you achieve this effect than create a flashy texture in the hair.

You'll be using drybrush again in this exercise, as well as scratching out light strands with your fingernail, brush tip, or razor blade. Remember that you can only "scratch out" in areas that are still damp; be sure not to overdo the scratching, or your result will be too "busy." You could also use opaque white to suggest strands, but I'd rather that you avoid opaque color until you've mastered transparent color. Opaque white can become the

"answer" to every mistake, and when it's used as a crutch, it seldom results in good pictures.

As you block in the hair mass, you might want to simulate the ends with a technique called "feathering." To do this, lift your brush gradually, as you end each stroke.

When you're waiting for a wash to dry, try to do something besides fiddle with your picture. Get up, stretch your legs, read a book. You'll come back with a fresh perspective, and the stage you're at might look fine to your fresh eye.

Since you're painting long hair, sketch in the whole head. Sketch in the face *generally*, with just the barest indication of the features. I want you to concentrate on the hair, not the face. The light here is coming from the right, slightly behind the head.

Dark Hair: Step 1. There are several approaches to take, once you've sketched in your subject. You could wash in just the face and wait for it to dry; or you could wash in the whole head and the hair area and wait for both to dry before going any further. It doesn't matter which approach you choose: the results will be the same. In this case, I've laid a fairly light wash over both the hair and face and allowed it to dry. For the lightest areas, you can leave some white paper untouched, and you can also blot them with a tissue to lift out the lights.

Dark Hair: Step 2. Since the hair is black, start right off with black paint. Have just enough water in your mixture to make the paint move. This dark wash should *not* be drybrush, and there should be no build-up of pigment. The wash should be dark, but always transparent—not opaque. It's important that you try to arrive at the right value as early as possible. You *can* correct mistakes in watercolor, but you shouldn't rely on overwashes to correct your values.

Dark Hair: Step 3. Continue to wash in your darks as you work down the left side. Feather the ends of the hair mass. (My first wash wasn't absolutely dry in the neck area, so some softening took place on the left when I painted in the hair. This was accidental, but it works well!) On the right, wash in the same dark wash, but blot it with a tissue to lighten the area, because it is effected by light. At the top of the head, use some drybrush, but don't overdo it—just a few strokes. Now, wait for the whole thing to dry.

Dark Hair: Step 4. Now, restate your darks. If you started with a good, rich, dark wash this will be just an emphasis of your darkest accents. I liked the soft edge on the left side of the neck, so I didn't let this area get too hard. Finally, scratch out a few light strands. Use a little dark background to make lighter strands stand out. Around the outside of the head, you can use dry-brush to suggest softness. Notice that I haven't outlined the face with my darkest darks; some hair areas right next to the face are slightly lighter. This allows the face to "breathe." Hard boundaries all the way around the face would have isolated it.

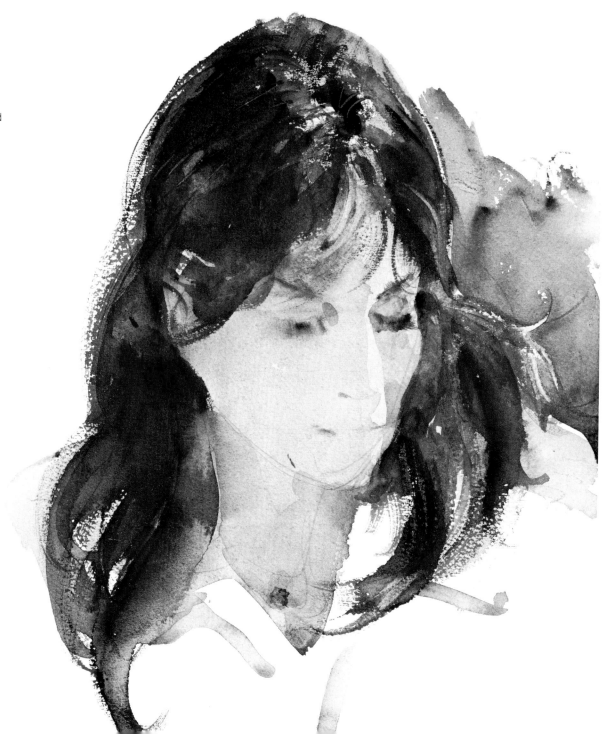

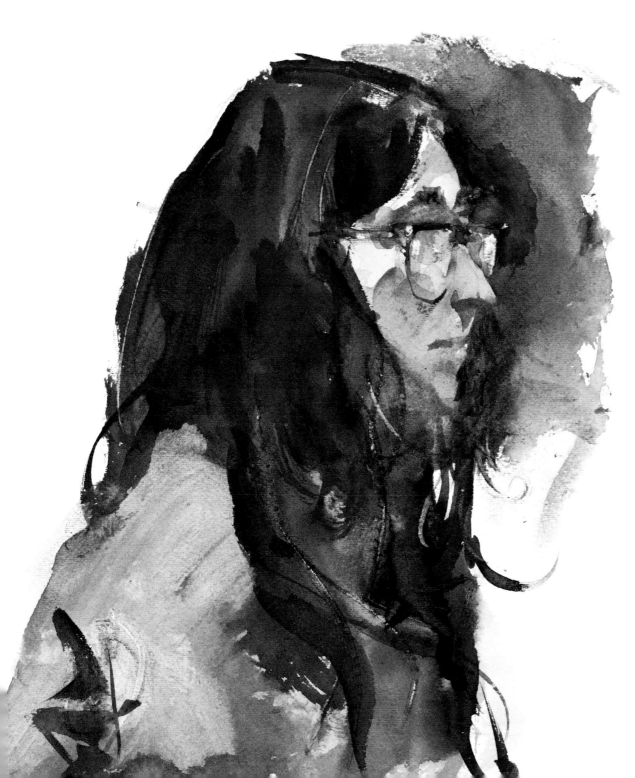

Chris. 8"x10", Fabriano paper. This is a very quick sketch. Compare the very soft edges in the hair on the far side of the head to the much harder edges where the hair meets the light-struck sections of the cheek and forehead. This is a good example of using harder edges to bring an area forward and using softer, more blurred edges to make another area appear to recede.

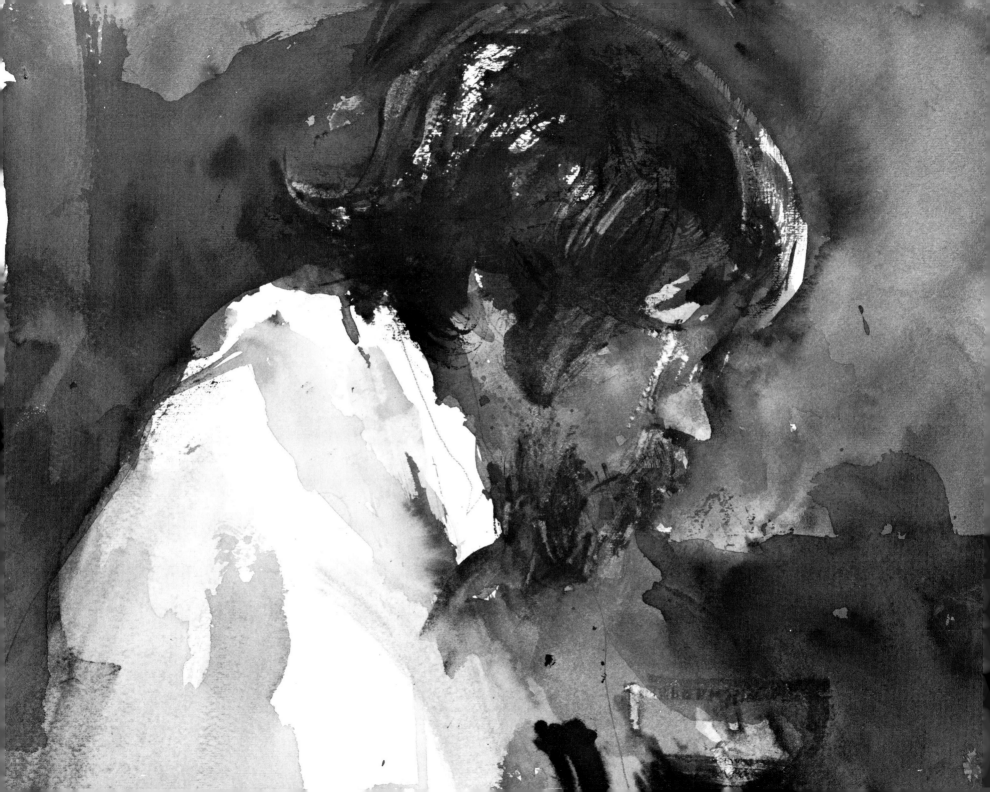

The Hands

John. 10"x12", Fabriano paper.
This was done in a sketch class while
the subject was working on a
painting of his own. Most of the head
was actually in shadow, and only the
nose and a little bit of the forehead
were affected by the overhead light. I
wanted to create the impression of
the head in shadow in contrast to the
white shirt. Notice that I scratched
out the rims of his glasses with a
razor blade and left some of the
white paper in the hair to show the
effect of the light.

13
Basic Hands

Drawing hands has always been difficult for me, and I still get into trouble when I do it. Because of my own difficulties, I feel that hands are the hardest part of the figure to draw. I strongly suggest that you find a good book specifically on drawing hands. I've included titles of several such books in the Bibliography in the back of this book.

Since the principles of drawing are beyond the scope of this book, I won't go into detail as you sketch a hand for this demonstration. However, I'd like you to keep in mind that the top boundary of the arm, the wrist, and the first finger can usually be described by one long, curving line (see Step 4). Obviously, this principle won't always work, but there is usually some way to indicate the relationship between the fingers and the arm—so watch for it.

For Step 1, I suggest that you use a 2B graphite pencil. Try not to use an eraser: erasing tends to disturb the surface of soft papers, and you can never completely "lose" a line when you correct with an eraser. Try drawing lightly at first, and don't worry about restating boundaries.

Basic Hands: Step 1. Begin with a single line to describe the arm, the wrist, and the outer boundary of the first finger. Retrace and extend this line to indicate the second finger. Then continue the same line around the tips of the second and third fingers, showing only the *indentation* between these two fingers. Now, go back to the first finger and continue your line around the tip and along the inside boundary until it meets the boundary of the second finger. Make a small dot to indicate the outside boundary of the fourth finger. Then go back and extend the lower boundary of the lower wrist up to meet this dot and continue the line around to complete the fourth finger. Finally, sketch a simple oval to indicate the back of the hand, and draw another light oval along the line where the knuckles will be.

Basic Hands: Step 2. Wash in your sketch of the hand with your light wash. Notice that I've tried to improve the shapes a bit with this wash. The drawing we just did is very general, lacking the particular small shapes that are normally important in drawing the hand. But I don't want you to worry too much about these small shapes, since this exercise is really just a beginning stage in learning to paint hands.

Basic Hands: Step 3. In this case, the wrist is bent downward and the light is coming from the right side: the area below the wrist is bent away from the light and is actually in shadow. Mix up a dark gray on your palette, load your brush with the dark wash, and give it a good shake. Then block in a simple, rectangular shape on the lower wrist area. Notice that the boundary of your shadow next to the hand should have an out-ward-curving, not an angular, shape.

Basic Hands: Step 4. While this wash is still wet, go on to the back of the hand, which is turned only slightly away from the light. Use a middle value here. Starting along the curving line your drew earlier to show the knuckles at the top of the hand, wash in a value that's lighter than your shadow wash—*but not too much lighter!* You want definite, obvious planes on this basic hand. It would be better for this wash to be too dark than too light. I've made a rather wavy boundary along the knuckle line to suggest the bones in the knuckles.

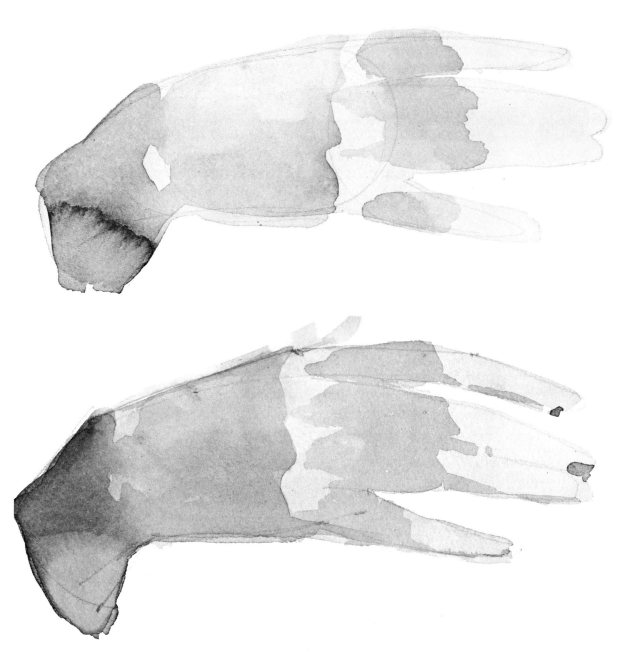

Basic Hands: Step 5. The back of the hand is a wedge-like form, and the fingers are attached to the wider end. Since the light is coming from the right, this wider area, where the fingers meet the mainpart of the hand is the lightest area. Don't touch this section with your middle wash; instead, go on to the fingers. The fingers are almost parallel to the back of the hand, so they don't catch much light. Starting with the first finger, block in a middle wash between the first, lower, joint and the base of the knuckle on each finger. Then draw some of the wash toward the back of the hand, almost connecting it to the shadow shape there. (Be careful not to destroy the light front plane of the knuckles.) The whole wash seems a bit dark in my illustration, so I'll blot it with a tissue.

Basic Hands: Step 6. Now you have a very basic hand that has form and mass. Add a few thin shadow indications at the bottom planes of the fingers and at the tips of the second and third fingers. Make these shadow indications very casual, leaving them broken here and there and varying their thickness. Finally, make a simple thumb silhouette, first with your light wash and then with some shadow wash. This isn't really necessary, but it helps make the hand look a bit better.

14
Hands in Detail

In this demonstration, we'll continue to paint simple light and dark shapes; but we'll also go a bit further and concentrate not only on the large planes that give the hand *form* but also upon the smaller shapes that give the hand *character*. However, as you've seen in earlier demonstrations, the student usually has to decide whether to concentrate on the big, simple shapes that indicate mass and volume or on the small planes and wrinkles that give the subject personality and character. My advice is *still* to make your development of big, simple forms *first* on your list. A generalized head or hand that has overall dimension will always be a valid form whereas a head or hand that lacks general form and is merely a confused jumble of details will almost always be a failure.

The hand I've drawn for this demonstration is a bit more complicated than the sketch we did for the previous exercise: I've indicated more relationship between the fingers, the wrist, and the arm.

But I think you'll manage if you recognize these relationships and continue to think of the fingers as an *extension* of the wrist. As you sketch, remember that hands are very graceful, and use graceful, flowing lines. It's important not to start out with a tightly clutched pencil and a tortuous, stilted line.

In Step 4, I've added more accents than we used in the previous exercise, but I've continued to *understate* the small forms. As you complete this step, see how much detail you can add without losing the *simplicity* that's so important. If you're a "detail person," add wrinkles to your heart's content—but be sure they don't overcome the simple form and graceful action of the hand.

We'll assume that the light is coming from above, so the major shadow shape will be on the underside of the hand. Continue with the same materials you've been using all along.

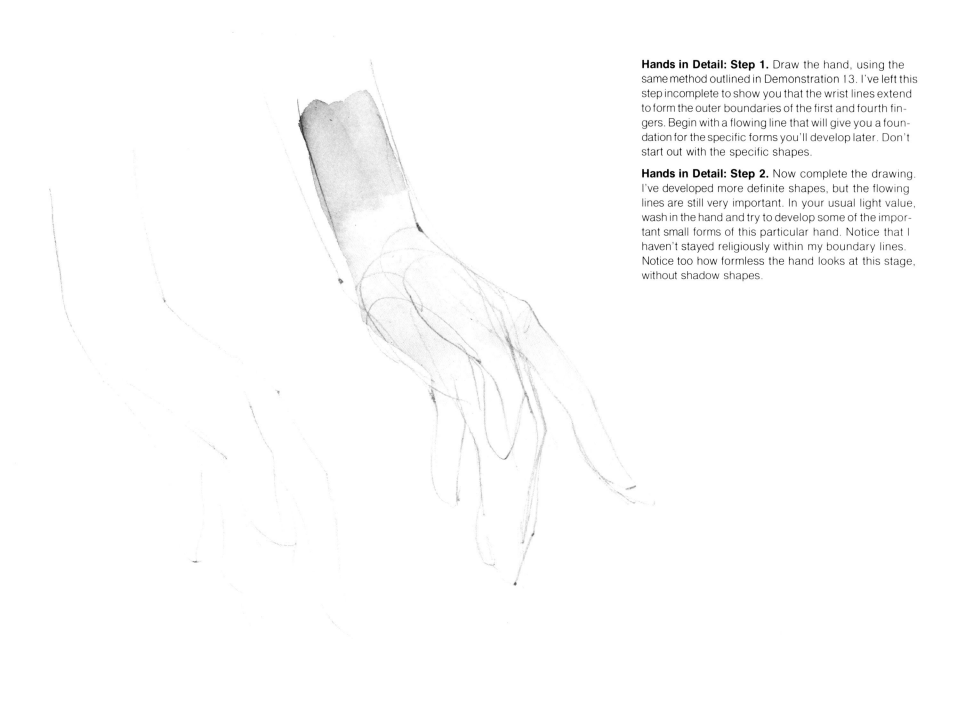

Hands in Detail: Step 1. Draw the hand, using the same method outlined in Demonstration 13. I've left this step incomplete to show you that the wrist lines extend to form the outer boundaries of the first and fourth fingers. Begin with a flowing line that will give you a foundation for the specific forms you'll develop later. Don't start out with the specific shapes.

Hands in Detail: Step 2. Now complete the drawing. I've developed more definite shapes, but the flowing lines are still very important. In your usual light value, wash in the hand and try to develop some of the important small forms of this particular hand. Notice that I haven't stayed religiously within my boundary lines. Notice too how formless the hand looks at this stage, without shadow shapes.

Hands in Detail: Step 3. Mix up your dark wash, and simply block in the shadow on the underside of the hand. Try to get as much mileage as you can out of this shadow shape. Let it go into areas which are not quite in shadow but are still darker than middle lights. In other words, generalize as much as you can with the many areas in the vicinity of the shadow that are close to the shadow in value. Before your wash dries, soften some areas where the boundary between light and shadow is subtle, at the forward edge of the shadow. Notice how this soft edge describes the ''fleshy'' areas in the thumb, leaving the more ''bony'' areas to be described by a harder edge.

Hands in Detail: Step 4. Now for the shadow under the first finger and the fleshy area at the base of that finger. A very hard edge separates the top plane of the thumb from the underside of the first finger area. The first joint of the thumb is bent, so the top knuckle is in shadow. Once again, generalize with your shadow shape, allowing some shadow to flow onto the top knuckle of the thumb. This value difference between the two sections of the thumb shows that the thumb is bent—an obvious statement, but a good example of how planes of light and shade can show the relative positions of forms. Leave a small light area at the end of the thumb to indicate that part of the fingernail is in light. Don't try to be too accurate here. Now, you can add more detail with small shadow shapes, but remember—keep it simple!

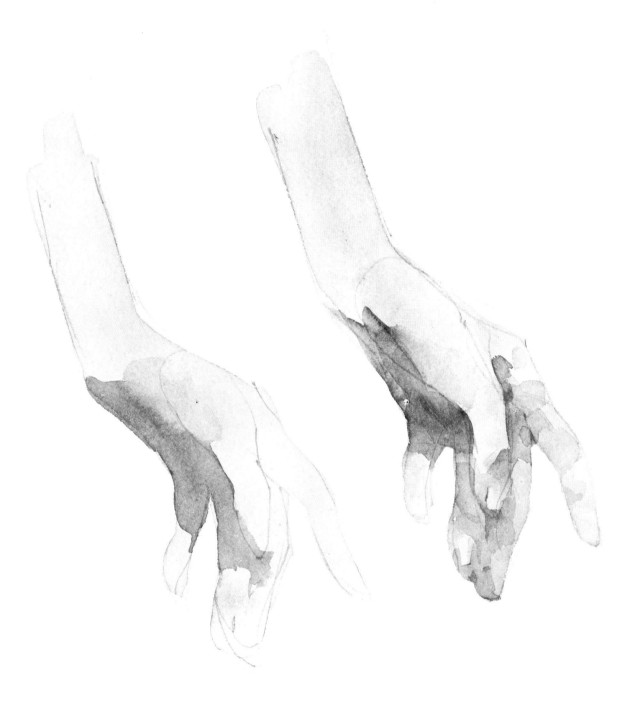

Peter. 8"x10", Fabriano paper. My son fishing from our boat. Although there are no distinct features in this head, it still looks a great deal like Peter. I carefully delineated the profile and tried to make the shape of the head as accurate as possible. I was quite intrigued with the chance to develop form in a very simple way, using the light-struck sections of the back. Notice the suggestion of light just above the trousers on the right side and the very subtle reflected light on the left side. I blocked in the entire shadow using several colors, then blotted the front of the torso with tissue to lighten the area and suggest reflected light. The trousers were very dark blue but, if I made them as dark as they actually were, they would have completely dominated the picture, and the head and upper torso would have become secondary. Be sure—and be willing—to understate colors and values in areas which you don't want to be particularly important.

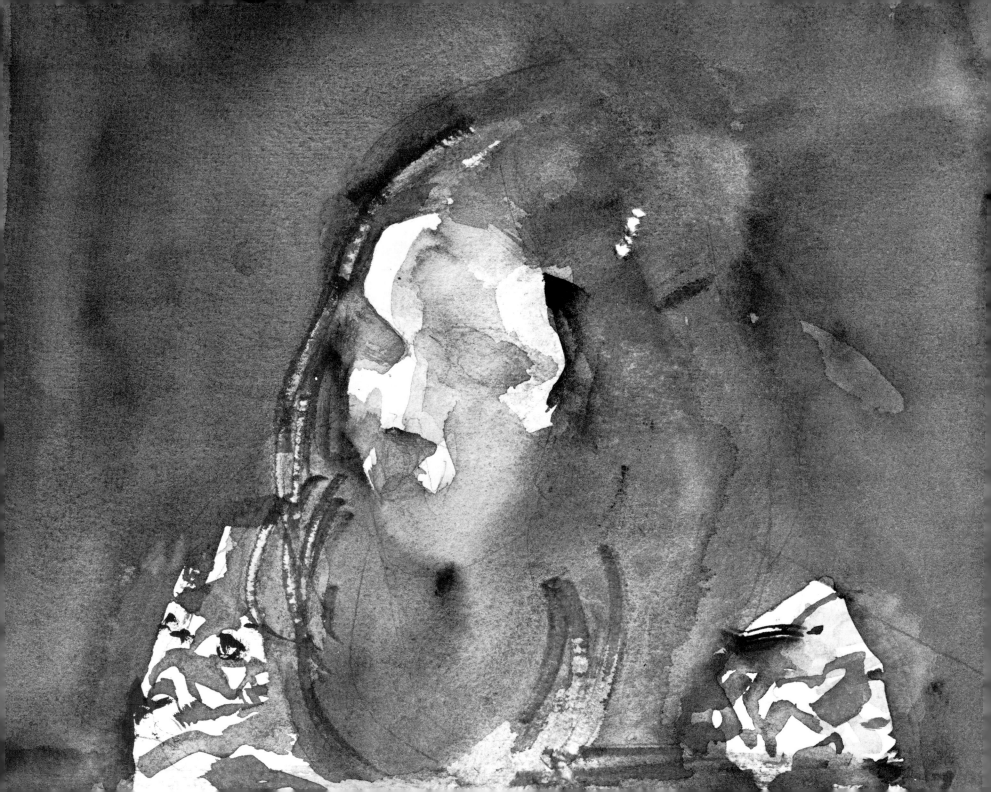

Portraits in Black and White

Shirt with Pattern. 8″x8″, Fabriano paper. This picture is very stark, with light hitting only certain areas in the head and shirt. The rest of the areas—the hair and the shadows of the face and shirt—are completely lost. To relieve the monotony of this rather stark picture, I quickly developed some of the patterns in the shirt. Although this was a very quick sketch and I really didn't get very involved with the pattern, I think something like this could be carried much further, with large, simple areas used in conjunction with much more involved pattern areas. Remember not to paint all of a picture the same way. When you use detail in a pattern, try to relieve that detail and pattern with broad, simple sections.

15
Child

In this exercise, we'll start using the ideas we've explored in earlier demonstrations. Much of the material will be repetitious, but I feel that repetition is one of the keys to learning, so bear with me if I've covered some of this before.

My daughter posed for this demonstration and she worked hard at it. If you have children, you'll probably find them reluctant subjects. The novelty of posing will soon wear thin for them, especially if you paint a lot—so don't feel guilty if you use photographs for reference. I used some Polaroid shots myself for this project.

One point about using photographs: at least for me, they don't give life to the subject, and I tend to labor over my painting when I work from a photo. You can avoid these problems if you use photos as a *reference* but try to work from *life* as much as possible. (You might also try painting children when they're watching television. They might look a bit vacant, but they usually stay still as statues if they're involved in a program.) Using photographs as your only reference is very difficult, so if you do paint a good portrait completely from a photo, be proud of it!

This time, as always, I've tried to use a natural, "unposed" pose. I think the most commonplace poses are usually the most interesting. Try to make your subject look just as he or she would if he were just sitting and thinking. As you get into the business of painting people, you'll start to think about gestures and to watch the way people sit and

stand. As you get into the habit of recording poses, a sketchbook will come in handy. Even if your drawings don't mean anything to anyone else, they can be a good source of ideas for poses and gestures for you. If you learn to paint people as they really are—and not as they look when they're posing—you'll be in good shape.

I've decided to paint the arms and hands, as well as the head, this time. This makes the problem a little more difficult but also more interesting. The light is coming from the right, so the left side of the figure will be in shadow. The materials for this demonstration will be the same as those we've been using right along.

In my preliminary sketch, notice that, although my drawing seems spontaneous and sketchy, I've considered two important elements: *shape* and *form*. I've drawn elipses, or ovals, *around* the head to help create the feeling of three-dimensional form. Remember that the head is a rounded form and that the features should describe this roundness. When you draw features, never place them on a straight line opposite each other without first establishing the form and mass of the head with your elipses. As I've said, *drawing* is very important, and this will be especially true in the following demonstrations; so please borrow or buy a good book on drawing. (Check the Bibliography in the back of this book.) The time you spend on drawing will pay off!

Preliminary Sketch.

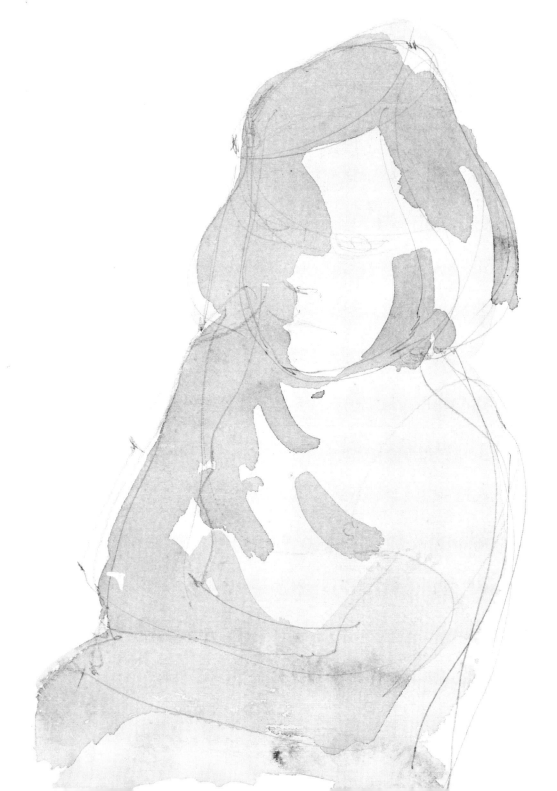

Child: Step 1. After you've completed your basic sketch, cover the skin areas, the hair, and some background with a light wash, and allow it to dry. Now, mix up a dark wash—and make sure it's dark enough! You'll use this wash for many of your shadow areas, and you should avoid restating it; so it's better to make it too dark than too light. Although the hair is blond, it's quite dark in many areas; so cover most of it with this wash and leave only a few light areas untouched. Go directly to the shadow side of the hair, the shirt, and the arms. Be careful of contours here, and try to make the shadow descriptive of the shapes on which it lies. Don't get too involved with folds, but block in *some* of the folds of the shirt that are in shadow. More important, notice that all the shadows, regardless of how light or dark the area, are blocked in with the same wash for now.

Child: Step 2. Before this wash has a chance to dry, soften some edges and make some middle values. Starting with the hair, lighten the top section with a damp, clean brush. (Remember to give your brush a good shake after you rinse it! In this case, there was a bit too much water in my brush, and the shadow on the forehead was disturbed.) Without going back to the water supply, use the paint you picked up on your last stroke to add some middle tones to the light side of the hair. State the middle tones on the front planes of the left cheek and soften the front of the nose. Even with all this softening, many hard edges will remain and some new ones will be created. Don't worry about this. Softening every edge will just make your watercolor look labored-over and "flabby." Notice how dark the left arm seems. I've used the same value in this arm that I used in my shadow area. Before it dries, I'll blot it with a tissue to bring it up to a lighter value.

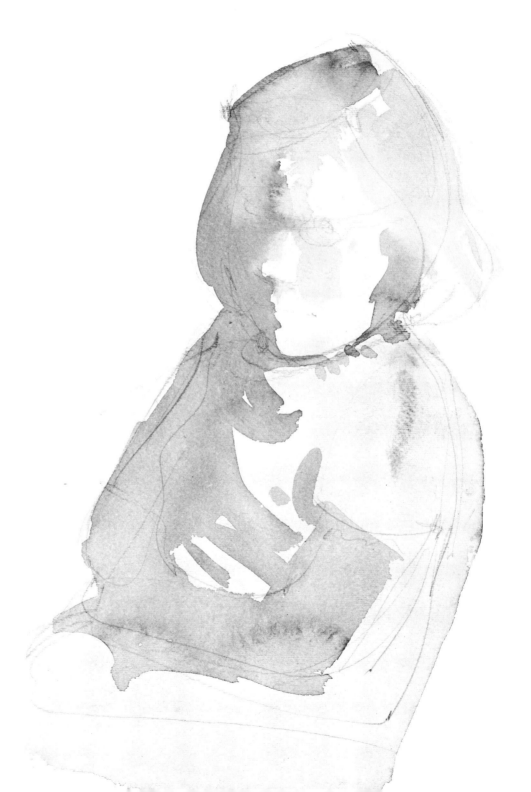

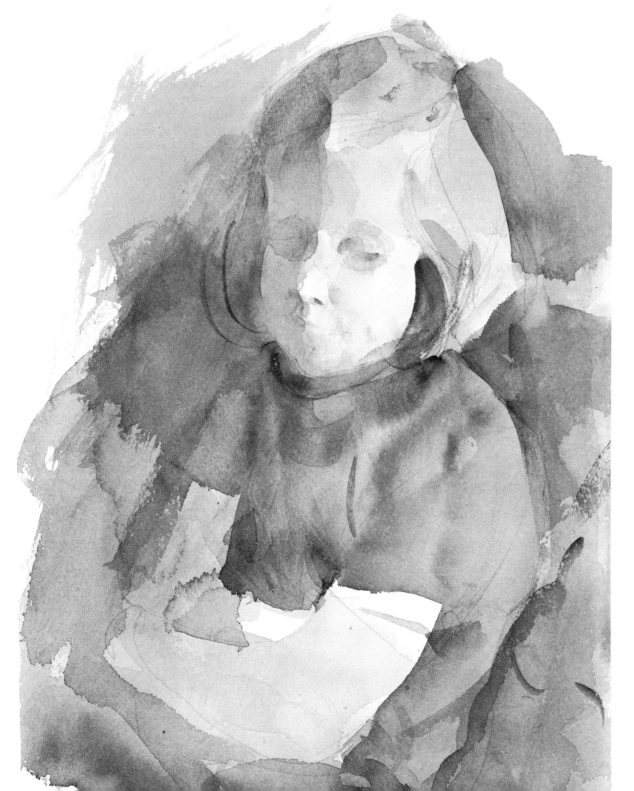

Child: Step 3. A lot has happened! I think the picture looks too washed-out with light, subtle skin tones and a light shirt. So let's throw caution to the winds and make a dark shirt and add some darker background. Now the skin tones will be a light silhouette against fairly dark surroundings. Add some darks in the hair on the shadow side of the head to make the left side of the face lighter by comparison and create a feeling of reflected light in the shadows. The eyes are looking down; the right eye is hardly noticeable, since it's completely in shadow. From experience, I know it's harder to paint an eye in shadow, so let's merely state a darker socket area and put off the problem of painting it until later. Any feature in shadow must be more subtle and less important than a feature that is in the light. I feel it's often better to leave out or barely indicate features that are in shadow, but often this isn't possible—it depends on the lighting situation and how detailed and "finished" the picture is going to be. Notice how fluid the painting is at this stage.

Child: Step 4. With the finishing touches, we'll be done. Add the barest indication for the eye in shadow—just enough to show it's there. (I had to blot this eye out several times, wait for the paper to dry each time, and try again, until I got it right!) Now, harden some areas and try to make some features more definite. Lift out a few areas of the hair in shadow to suggest reflected light. Some dry brushstrokes and some folds added to the shirt—and we're finished! I'm always afraid I've gone too far, over-hardening and over-defining. It's better to leave a picture understated than to work at it too long, or the result might be a haggard, tired painting!

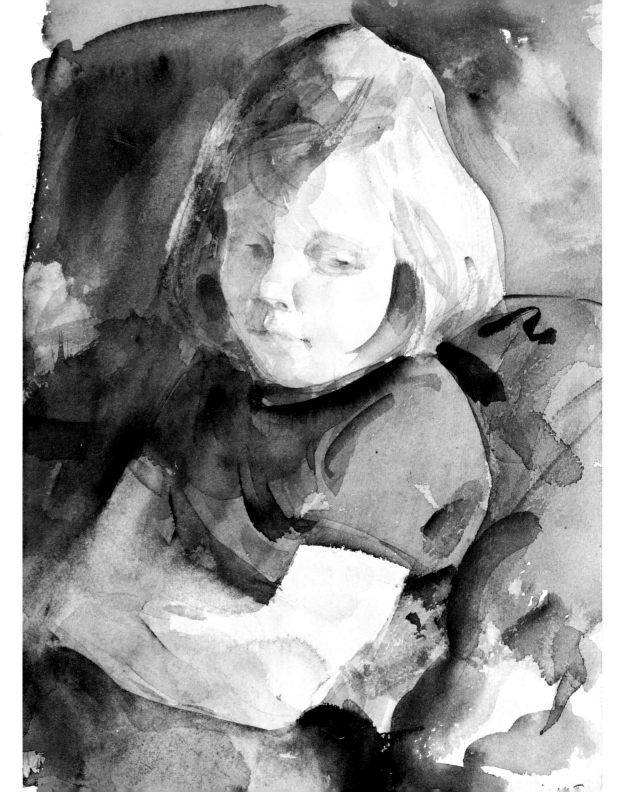

16 Young Woman

In this demonstration, we'll have two important lights shining on the subject. As you know, I've been stressing the importance of using a single light source to create one simple shadow and one simple light area. This lighting situation is always valid and is always the easiest way to show form. On the other hand, it's not always the most interesting way to illuminate the subject. By now, you should be ready to try something a bit more adventurous.

In this case, we'll still have some definite shadow shapes to work with, because one light will come from either side of the head to create a shadow shape almost in the middle of the face. This lighting situation is similar to the one in the demonstration on Rim Lighting, p. 34, except that the shadow won't cover the entire front of the face this time. The main light will come from the left side; the secondary light will come from the right and slightly behind the head. This secondary light creates a smaller area of light on the *right* side of the face than the main light does on the left. The left side will be almost completely out in the light, while the right side will be partially in light and partially in shadow.

We'll concentrate on structure here, and I'll try to show you how light and shade can create the three-dimensional form of the head. We'll try to create the feeling of the skull beneath the surface details—such as the eyes and mouth—that we normally see. Of course, in some lighting situations it's impossible to see this structure. This is true, for example, when we have a diffused light coming from the front. In this case, we see practically none of the bone structure but only the features. There's nothing wrong with this situation, and some paint-

ers handle it very well; but unless you *know* the structure, the features you paint will often appear to be floating in a void. In this demonstration, we'll almost forget about the features in an attempt to interest you in structure.

As you make your preliminary sketch, keep it loose and spontaneous; the features are going to be vague. Concentrate only on their positions in relation to each other and to the head as a whole

Preliminary Sketch.

Young Woman: Step 1. Wash in the entire head, including the neck, with a light wash. Allow this to dry.

Young Woman: Step 2. Now mix up a much darker tone. You'll be drawing parts of this dark wash out into the light, so start with a darker wash than you think is necessary. (Remember that your wash will dry *lighter* than it seems when you first apply it.) Load your brush, give it a good shake, and start washing in the hair. Continue the shadow on to the right side of the face without interruption, and don't make a distinction between the hair and the skin in this shadow area. Be conscious of the planes here. This darker wash should go *around* the area above the lip, stopping about three-quarters of the way around to the left. The dental arch causes this area above the lip to form a side plane that catches the light on the left. If your wash is too dark, be ready to go back to your water jar and rinse out some of the darker color. Blot or shake the brush to get rid of excess moisture, then go back to the paper.

Young Woman: Step 3. Allow this second wash to dry. It's possible to continue working on some areas without a pause, but I think it would be easier to take a break and allow everything to dry. Now, the left eye is quite dark, so mix up an even darker wash than you mixed for Step 2 and block it in. Then restate the shadow on the right side of the face, using one connected stroke. Your brush shouldn't leave the paper as it follows the front plane of the cheek down around the contour of the lip and back to the undersection of the mouth. This wash should be your final large, dark wash, although you'll need a few *smaller*, darker accents. Try to make this large shadow area dark enough and as accurate in contour as possible.

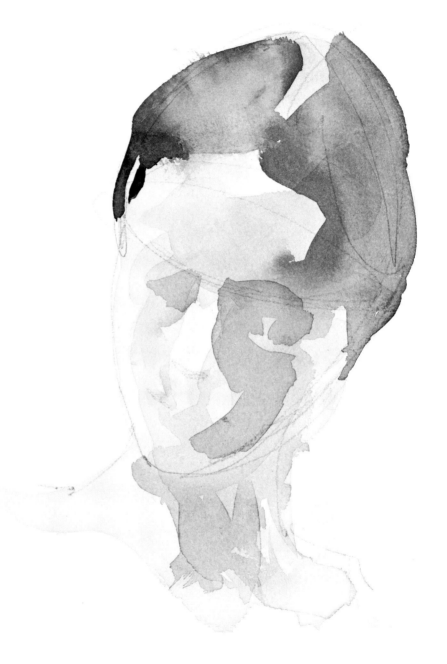

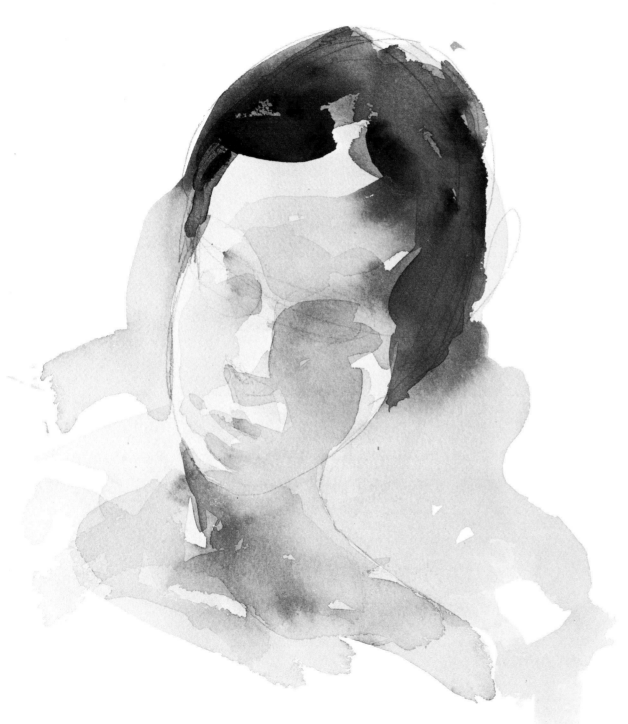

Young Woman: Step 4. Now brush the dark shadow shape in a few places, working it down to the chinline and the neck with a damp brush. Notice that I've restated the hair and allowed it to blend with the middle value in the right side of the forehead. I've also drawn in a shadow shape under the nose to indicate the cast shadow which will help make the nose project from the face. I think you can see that the main shadow on the right side of the face has become lighter as I worked it out into these areas. If you didn't start out with a dark enough shadow, this process of lightening will destroy any feeling of shadow, and you'll have to restate it. If you did start with a dark enough wash, there's no problem; just be sure the face is dry before you make your restatement.

Young Woman: Step 5. Now, for the final step. The right eye is quite dark, so give this another wash. Be careful to show the form of the eyeball here. The darkest dark should be near the nose bridge; the eye area becomes slightly lighter across the eyeball, then quite dark again just before you reach the small light-struck area on the far right side of the face. Now harden up some edges and soften others. You can see a good example of edge variety on the left side of the face in this illustration. Restate the dark accent on the cheekbone on the right side of the face to show the bony structure of the face. Notice that, except for the eye area, this small accent is the darkest shadow area. The edge of this accent should be quite hard before it meets the small light-struck section of the cheek. Restate more of the background and add a few minor details. Now we have a face that's quite featureless; but try to think of this demonstration as an exercise, rather than as a guide to a finished painting.

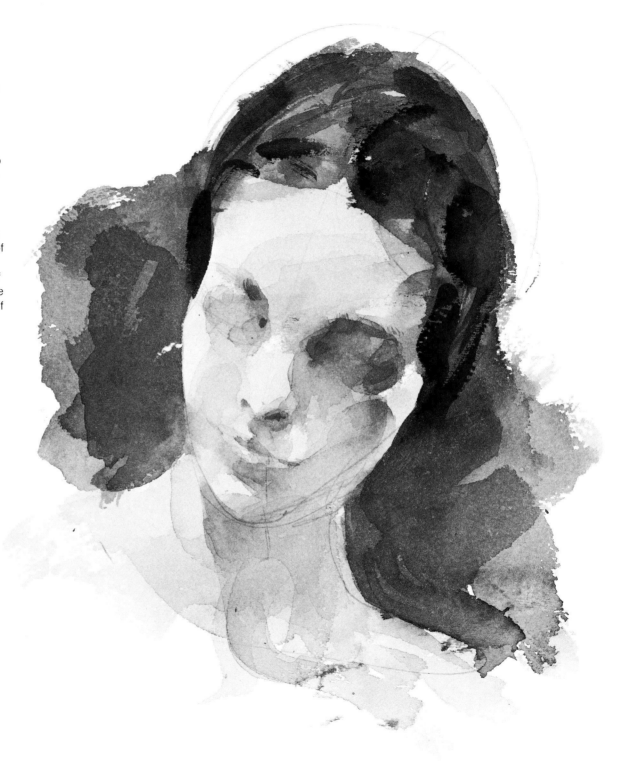

17
Young Man

Preliminary Sketch.

In this demonstration, we'll use a slightly different approach: this time, lighting will be a major factor as we begin painting the head. I feel that painting *light* is as important as painting a likeness or a characterization, and I always strive for a feeling of light in my paintings. The effect of sunlight on a head or figure never fails to "grab" me. The large and small patterns that result from sunlight striking a cheek or an ear can be the whole point of a painting for me. In this exercise, we'll try to capture the feeling of sunlight using only light and dark values. Color is also very important, but here, let's see what we can do with black and white!

Our subject will be a young man, looking to the right (the painter's right), with the sun behind him. Most of his face will be in shadow, but there'll be some light striking his ear, cheek, and hair, and we'll leave the white paper untouched in these light sections. In Step 3, notice where I've placed my darkest shadow areas. As a rule, you'll find the shadow is darkest along the line where it meets the light area, because this strip is usually on a plane that does not catch either reflected or direct light.

In this case, for example, the shadow on the front plane of the face is catching reflected light, the side plane is in direct light, and the strip between is darkest. This strip does not face the source of the reflected light, nor is it turned to catch the direct light.

In this view, with so much of the head in shadow, it's very important that you don't allow your darker darks and your lighter areas of reflected light to confuse the overall value of the shadow area. No-

tice in Steps 4 and 5 that we still have the overall feeling of shadow on the front of the face, and that no *shadow* area is as light as the main *light* area. (We'll make this very important distinction between light and shadow by covering all the shadow areas with a medium wash in Step 1; we'll leave the white paper under the main light areas untouched.)

Notice also the features that I've added in Step 5. They're subtle: they must not be too dark, or they'll look more like holes in the head than like eyes, nostrils, or mouth. The features must be just dark enough and no darker. I'd strongly advise that you make the features hardly noticeable, rather than take a chance that they'll be too dark. If you study many heads in shadow, as I have for this book, you'll see what I mean.

When you paint teeth in shadow, remember to paint right over them with your shadow wash. In some cases, you might blot them a bit to make them slightly lighter than their surroundings, but *never* use opaque white or leave the white paper under them untouched. The same goes for the whites of the eyes. In both cases, you can offset these features by adding a few darker accents. In Step 5, for example, I've added some subtle darks on each end of the mouth.

Your materials will be the same as usual. Be sure your brush is still in good shape, after all the demonstrations (I hope) you've been doing! It should still point nicely. You can test it by giving it a shake and running it along the palm of your hand.

Young Man: Step 1. On your palette, mix up a fairly dark value—darker than the first washes you normally mix, but not as dark as your usual shadow value. Load your brush, shake out the excess moisture, and block in the big dark areas. I often establish my final shadow value in this first wash; this involves some very subtle work, using both wet-in-wet and lifting out lighter areas while they're still wet. For this demonstration, we'll establish the lighter values now and add the darker areas when this shadow wash dries. The hair is also quite involved, so for now, don't do much to it. Remember to leave the light-struck section of the cheek and ear untouched, as well as the light-struck section of the neck.

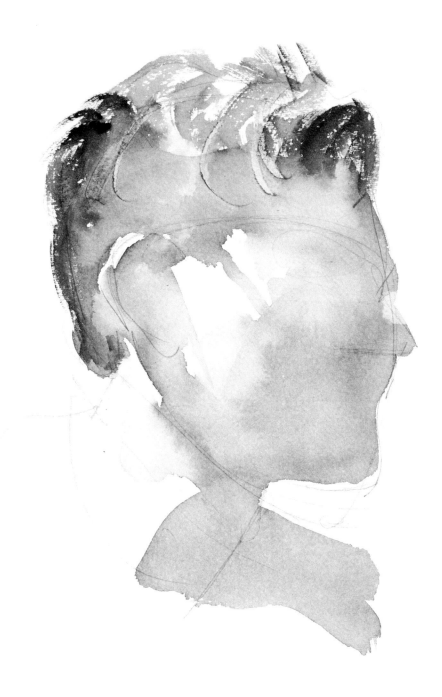

Young Man: Step 2. Now soften the edge that separates light and shadow on the cheek to show the rounded form of the cheek. Notice that the edges on the cast shadow remain harder. Then, on to drybrush to show the hair. It's important not to overdo this drybrush, so don't get too involved—just make a start and save the finishing touches for later.

Young Man: Step 3. Put in some darker hair values near the ear and forehead and, while they're still wet, scratch out some lighter strands. With a darker strip of wash, restate the edge plane that runs up the cheek. Try to make this strip quite dark, since it will be diluted and lightened as you soften edges and make the necessary gradations on either side of the edge plane. I've started adding some background to offset the light-struck sections in the hair and back of the neck. The subject is smiling, so the dental arch is turned back slightly to form a partial side plane. Add a little darker wash here and along the nose—another plane that's turned slightly away from the reflected light. Establish the large construction of the mouth area before you put in the lips, and develop the planes of lighter and darker values around the eyes before you put in the lids.

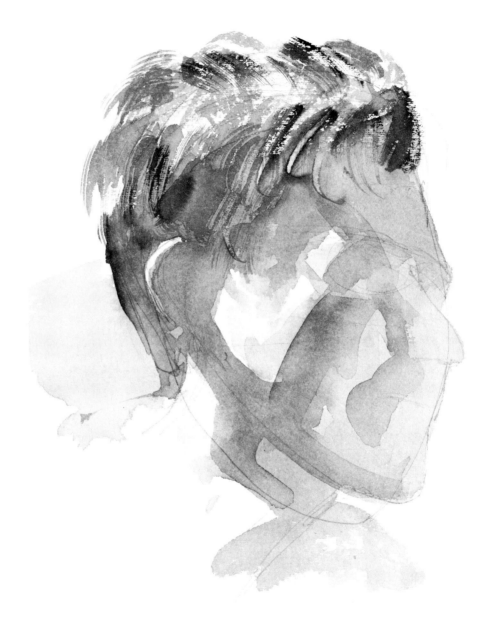

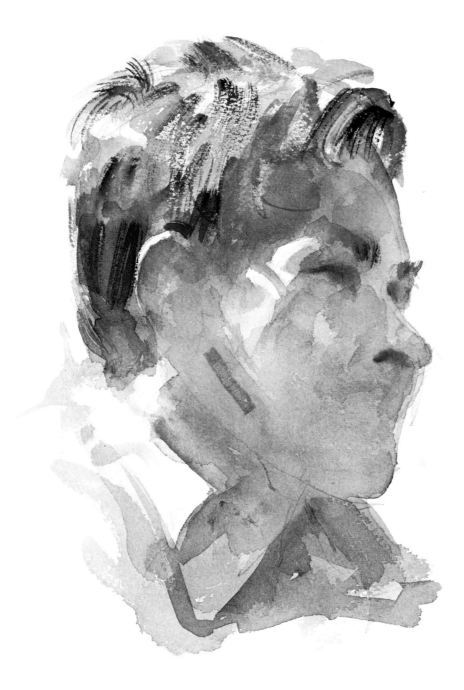

Young Man: Step 4. It's difficult to show you a gradual transition into this step and the final step. We did the basic work in Step 3, but the finishing touches in these final steps will bring the picture together and give it reality. Up to this point, we've been interested only in establishing the structure and simple planes of the head. In this step, don't let anything destroy these simple planes as you add more detail to the eyes, nose, and mouth. As I've said before, the greatest danger is that you'll allow your interest in detail and characterization to destroy the simple planes and the form of the head.

Young Man: Step 5. Create a feeling of teeth by adding some subtle darks on each end of the mouth. The whites of the eyes don't really show up in this particular head, so don't worry about them. Scratch out some hair strands and add more drybrush, both in the hair and skin. After your basic values and edges are established, you can add very careful drybrush work to suggest texture and to darken a few areas that need help. Drybrush is also helpful to soften edges, but don't overdo it. I've used a little drybrush on the edge of the cheek, where it emerges into the light. This step has more of an impression of detail, since I've used more drybrush, but it's still quite broad and simple. It's not the detail that makes this head effective; it's the simple planes of light and shadow that make it work.

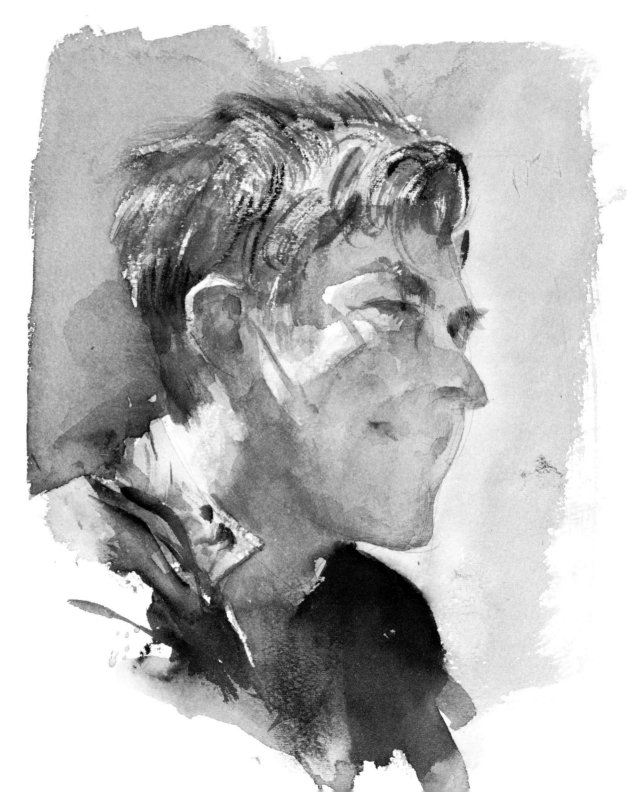

18
Older Man with Beard

Preliminary Sketch.

In this demonstration, our subject will be an older man with light hair and a beard, with a simple direct light shining on the front of his face. This light will bring out the many small planes that describe and give character to the features of older people. In the proper lighting situation, these planes make painting older people both fun and easier than painting most younger people. (One exception to this is men from their twenties on: their strong, salient features make them relatively easy to paint.) Children are more difficult to paint because they have smoother faces, and their features are not as developed or apparent as those of older people. And problems also arise in painting women of all ages! Obvious planes of light and shadow can make their features appear "craggy," and a much more delicate and less obvious approach is desirable—with more subtle light and dark planes indicating the smaller features.

Older men, however, provide the painter with an excellent opportunity to develop the small planes that give the head "character," and their obvious features are really quite easy to paint. Because of this, I think this demonstration will be fun—and a bit simpler than some of the preceding exercises!

For this demonstration, you'll be softening many of your shadow edges before they dry, to show the rounded shapes of the cheeks, forehead, etc. Re-member never to soften *all* of your hard edges systematically. Try to retain some of the prominent, definite structure in this subject's face. Some "blurs" will be an asset to the painting, of course, but don't let too many areas of your shadow wash blend with the wet background. If you over-soften, the structure will be lost and the face will look like a marshmallow. Remember also to make your shadow shapes dark enough. Try very hard not to be timid about your shadow washes, or your shadows will be too light!

I've heard painters say that the background of a painting is more difficult to paint than—and certainly as important as—the head itself, and I think these are two good points for you to keep in mind. Painting the background in the right value is as important as painting the face in the right value: a background that's too uniform or too dark "kills" the atmosphere—the feeling of "air"—in the picture; and a background that's too light won't offset the subject properly. So, as you complete the head in this exercise, try to work in on both areas—head and background—at the same time, with equal thought and effort.

Continue to use the same materials you've been using right along. Sketch in the head, using your 2B pencil. We have a profile here, and the features are quite easy to "catch hold" of.

Older Man: Step 1. Mix up a normal light to fairly light wash. Load your brush, give it a good shake, and wash in the face and background. Don't work on the areas of the hair and beard that are effected by the direct light. In the illustration, notice that the side and back sections of the hair are included in this light wash.

Older Man: Step 2. Now for some darks. Mix up a dark wash on your palette, load your brush, and give it the customary hard shake. Start out with some very definite, "blocky" shadow shapes on the forehead. Don't paint over what will be the hair area around the temple and above the ear. Restate the background adjacent to the face to offset the light silhouette of the face against the darker background. State some very definite darks around the eyes and nose, keeping the painting fluid as you control the areas where the wet background and the wet shadow wash blend. I've left most of the dark statements on the forehead and around the eye and cheek as I originally stated them, doing no softening here, so you can see exactly how directly you should work. On the nose, however, I've started softening the mid-section, where the nose normally flares out a bit toward the cheeks.

Older Man: Step 3. Now, work back and forth between background and head, as you finish "washing in" both. In my illustration, notice the areas in the hair, the eyebrows, and the lower cheeks that I've blotted with a tissue. I did this to create the lighter values in the hair areas and also to make soft transitions between skin, hair, and background. Soften many of the hard edges in your shadow shapes, but remember to leave some of them hard. You can see the contrast of hard and soft edges quite clearly in this illustration.

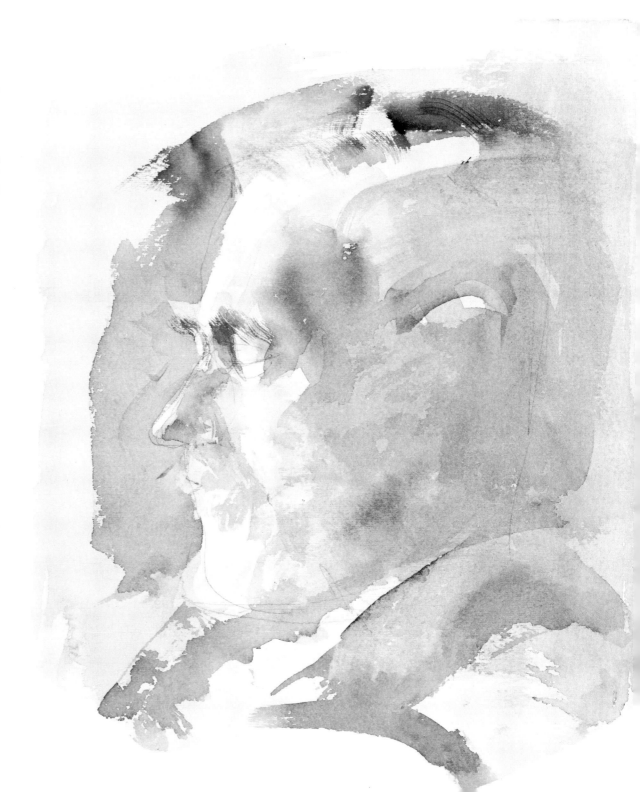

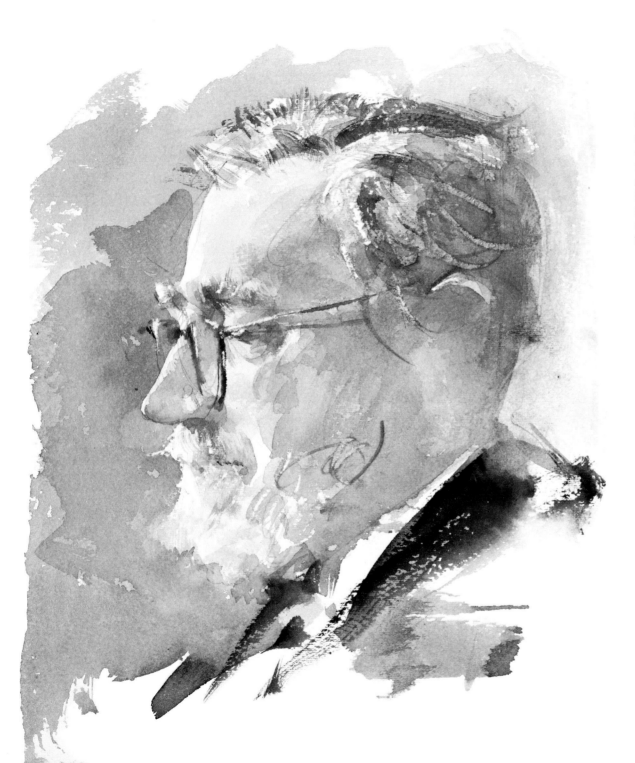

Older Man: Step 4. Darken the background and "tighten" up the head. Scratch out the rim of light that runs down the front of the nose. I've added glasses, but notice that I haven't rendered the rims completely: I've just suggested them. I've also scratched out some highlights on the glasses with my razor blade, as well as some strands of hair, which catch the light. Again, don't overdo it with your razor blade! Consider shapes carefully here. For example, the nose isn't just *any* nose, it's a *specific* nose. The hardening and softening of the boundary between the light-struck rim and the side plane shadow shows the conformation of *this particular nose*. I hope you're aware of the subtlety in an area like this. It really makes a difference!

19
Dark
Complexion

In this demonstration, we'll paint a subject with a dark complexion, under a fairly strong light source. Our problems here won't differ greatly from those we've had in previous exercises: the only important difference will be in the contrasts between *light* and *middle* values. In a light complexion, the light values are quite close to the middle values, with the major contrasts occurring between the light and the shadows. However, in a dark complexion, the middle values tend to be much darker than the light areas and are usually closer to the shadow in value. In other words, the greatest contrasts in a light complexion occur between the *shadows* and the *lights*, while, in a dark complexion, the greatest contrasts occur between the *lights* and the *middle* values.

As you block in your light, middle, and shadow values, be sure you understand the reason for giving a particular area a shadow, middle, or light value: the value of the area depends on the position and strength of the light source—or sources—as well as on the structure of the head. Never drop in lights or darks without a reason. I've included the sketch on p. 127 to show you why certain areas of this particular head should be light in value. The very light areas on the head will indicate where the "corners" of the planes (the edges where one plane meets another) are catching the light. In a light complexion, we might simply highlight these corners; and, since we should underplay highlights, it's very likely that we'd make these corners only *slightly* lighter than the adjacent plane of light. However, in a dark complexion, these lighter corners are much more obvious—and we'll make them significantly *lighter* than the adjacent light plane.

Remember also that an abrupt transition from skin to hair will make the hair look like a wig. In Step 4, when you restate the areas of the hair in light, *don't* paint right down to the point where the hair meets the skin. Keep your darks in the central hair areas, so that you develop a gradual transition from skin to hair. In the illustration for Step 4, notice that I've worked my dark wash around from the light side of the hair to the shadow side of the face and then worked it *into* the side plane of the head that is in shadow.

As you restate your shadow areas, hardening and softening edges, try to avoid any sense of hardness or a metallic look—and be sure your boundaries are as accurate as you can make them. Move slowly as you "find" your boundaries, and take your time deciding where they'll be. In Step 4, for example, notice that I've added a dark value with a more definite edge under the chin to give this area more definition. Near the right eye, you can see a much less obvious example of finding edges, where I've started to define the boundary of the head in shadow.

In the same illustration, notice that I've picked up the beginning of the jawline under the right ear. The trick here is to avoid working with one continuous dark outline around the face. Instead, pick up a dark here and there, and gradually work in dark areas around the face. You'll eventually connect these areas as you finish the head.

I've already stressed the importance of developing the *structure* of and area *before* adding the details. In Step 4 again, notice that I haven't worried about the whites of the eyes: I've painted right over the area they'll be in and stressed the *form* of the eyeballs and sockets. Use this principle as you work on the mouth, too: keep the *form* of the curve of the teeth in mind, and don't draw the lips with a

straight, dark line. This model has a prominent tooth line, and the upper lip doesn't project very much; so there's no dark shadow below the upper lip (although this lighting situation *could* create such a shadow, if the upper lip projected far enough).

When you complete Step 4, the form of the head should be well established, and your job in Step 5 will be to complete the head without doing damage to the three-dimensional form you've developed. As you add more darks to the hair and continue to define the boundaries, try to create the impression of very dark hair without painting it as a flat, dark mass. In my illustration for Step 5, take a look at the soft edges and the value variations in the hair. The lighter areas among the darks are subtle, but if you look closely, I think you'll see them.

In this final step, you'll also add detail to the eyes. Again, work slowly and remember that the iris must always appear to be *part* of the eye as a whole. Never indicate an iris with just a big, black circle. (Notice that I've added soft edges around the iris of each eye.) As a rule, you should try to add a bit more detail to the eye that's out in the light, or closer to you, whichever the case may be. You'll also see that I've scratched out some high-lights on the nose and around the right eye in Step 5. Use this technique very carefully: try not to dig into the paper, but gently remove the paint from the surface.

This will be our last demonstration using grays. I hope you've learned something about using val-ues and handling paint. In the following demon-strations, we'll add another dimension to our paint-ing by using color; but the principles you've learned so far will still be extremely important.

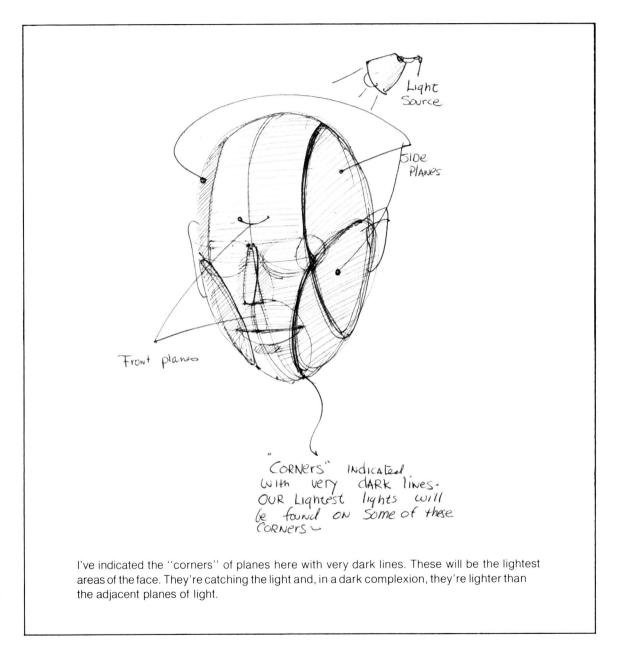

I've indicated the ''corners'' of planes here with very dark lines. These will be the lightest areas of the face. They're catching the light and, in a dark complexion, they're lighter than the adjacent planes of light.

Dark Complexion: Step 1. Make your preliminary drawing and cover it with a light wash. Although we're dealing with a dark complexion, your first wash should be just about the same value as the first wash you'd mix for a light complexion. Naturally, there's no single light value that stands for light sections on all complexions: we're generalizing here to find a light value that will work in most situations.

Dark Complexion: Step 2. The light is coming from the right, so mix up a dark shadow wash and block in the shadow shapes on the left side of the face, washing in the darker hair at the same time. Be sure these shadow shapes are quite dark. They'll have to do a major part of the work as you develop the head. So far, this is just the same procedure you've used right along.

Dark Complexion: Step 3. While your shadow shapes and hair areas are still damp, allow your darks to flow out into some of the areas that you left untouched in Step 2. Continue to leave untouched the areas that will be your lightest lights: the nose, the area above the upper lip, the top plane of the right cheek, a spot on the forehead, and the lower lip. Form the bottom plane of the lower lip by extending the shadow that runs down the left side of the face. Allow these middle values to dry.

Dark Complexion: Step 4. In these final steps, you'll do more work on both your lights and middle lights; but, by now, they should be generally the way you'll want them in the final stage. Back to your palette: mix up a rich, dark value and restate the shadow shapes and the darker values in the hair. On the mouth, add a few dark accents to indicate the division between the lips. Begin with the darker accent at the right corner. Then, in the center of the mouth, add an accent that's not quite as dark as the one you used at the corner. Leave the lower lip as a lighter value. Indicate the *form* of the eyeballs and sockets with dark accents at the corners.

Dark Complexion: Step 5. Now that you've indicated the form of the eyes, all you have to do is add the eyelids and irises. Begin by filling in the entire right iris with a middle value. Then, while this wash is still wet, add a very small black dot at the top, using wet-in-wet. Next, indicate the lower lid with a lighter strip. (You might also scratch this out or dampen the paper and lift it out with your brush to create a lighter value.) Now, darken the bottom plane of the right eye, to help keep the feeling of the rounded form within the socket. Use the same procedure on the left eye, but add a bit less detail here. Notice that I've softened the cast shadow under the nose and added a dark accent for the nostril. I've also used a darker wash on the right side plane of the face, leaving the right ear and the front plane of the cheek as a light value. Finally, darken the plane under the lower lip to make the mouth appear to project.

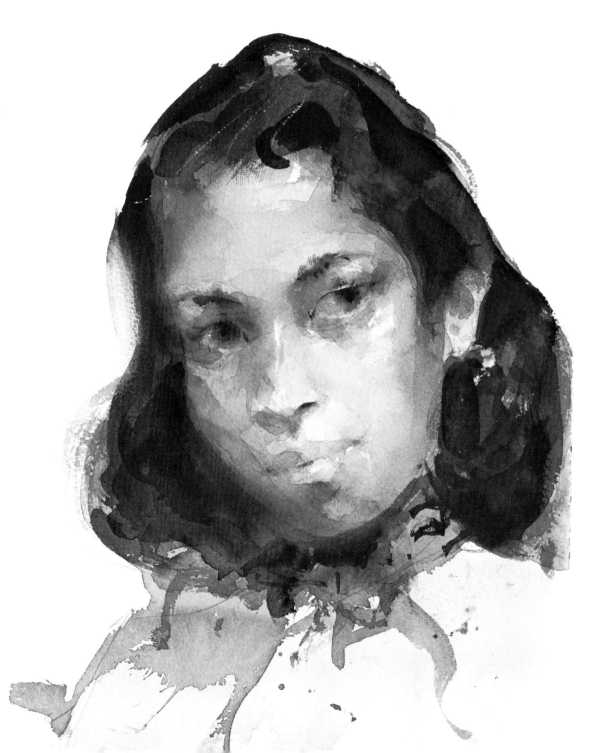

Portraits
in Color

20 Selecting Color

We've finished with grays, thank goodness! We'll do the remaining demonstrations in color, and they should be more fun.

In addition to being fun to work with, color also provides us with another tool to use in creating three-dimensional form. As you may already know, cool colors—blues, blue-greens, and purples—tend to "go back" or recede, making the cooler areas of a painting appear distant. On the other hand, warm colors—reds, oranges, and yellows—tend to "come forward," making the warmer areas of a painting appear closer to the viewer. This means that we can use cool colors in areas that we want to appear distant, and warm colors in areas that we want to come forward.

Naturally, this is a simplified explanation of the use of color. Sometimes, we'll find a warm area in a distant spot and a cool area close to us. For example, the ears tend to be warm, while the area around the mouth is usually rather cool. We'll get into the specifics of where to use what color as we go through the following color demonstrations.

For now, I'll list a variety of tube watercolor paints I think you should try. These are my personal preferences: if you've developed a palette you like, you should certainly stick with it. Color selection is personal, and we all have different ideas of what makes good color.

However, the colors I list here may appeal to you, so do try them! I've suggested them with ease of handling in mind: you'll find that many colors are hard to work with when you're mixing flesh tones, and that other colors may be simple enough to handle, but don't result in very exciting flesh

tones. It will also be easier for you to follow the color demonstrations if you use the same colors I'll be talking about to mix your washes.

Cadmium red light. My "basic" red. It's really the only red I use to mix flesh tones. I've used cadmium red medium and cadmium red dark a few times without good results. In all honesty, I probably didn't give these darker reds a fair chance, but, as far as I'm concerned, they just didn't result in good flesh tones.

Alizarin crimson. This color is very strong. It has a very great tinting power and tends to dominate a mixture if the other colors aren't also very strong. Alizarin is a must for mixing rich darks in darker complexions, clothing, hair, and backgrounds. Have it on your palette, but be careful when you use it in lighter complexions.

Cadmium orange. I don't use this color very often and I rarely use it as an important part of a flesh combination. But a touch of orange can be useful in pepping up a light area that's too cool and washed-out, and it can sometimes breathe life into a light flesh tone.

Cadmium yellow lemon or *cadmium yellow pale.* Both excellent yellows. They're the only cadmium yellows you really need. I find cadmium yellow medium too "hot," but many artists like it very much.

Hooker's green. The most useful green. Some artists prefer to mix up their own greens with blue and yellow, and you *can* get by without a tube of green. Personally, I like to have it ready-mixed, and I al-

ways have Hooker's green on my palette.

Sap green. This is weaker than Hooker's green. Again, you can get by easily without this color, but I use it quite often.

Viridian green. This is a very basic green in oil painting, but I find it too cool and metallic for watercolor.

Cerulean blue. This is a very useful color and one that finds its way into all of my complexions. I like its subtle, delicate mixing qualities. It's very easy to handle and it doesn't dominate a mixture.

Phthalo (phyhalocyanine) blue. This is the opposite of cerulean blue. It's much darker, richer, and stronger. Like alizarin crimson, it has great tinting powers and will dominate any combination if it's not used carefully. It's necessary for mixing rich dark colors. I use it often with alizarin crimson; these two strong colors are an even match. As you gain experience, you can use Phthalo blue in place of cerulean blue in very subtle, lighter areas. It's a beautiful blue when it's used well.

Ultramarine blue. I always used this as my dark blue until I discovered Phthalo blue. It's easier to handle, since it's not as strong as Phthalo; but, on the other hand, it has a certain harshness that I don't care for.

Yellow ochre. I use this color a great deal to mix flesh tones, and I interchange it with my light cadmium yellows. Yellow ochre is a weak and subtle yellow that mixes easily. This and the siennas and umbers listed below are the *earth colors.* As far as

I'm concerned, these colors are necessary to any watercolor palette.

Raw sienna. This is a darker version of yellow ochre. It's very useful in the shadow areas of flesh tones.

Burnt sienna. I don't use this color in flesh tones, but I do use it a great deal in other areas. It mixes well with blues and greens and can make some fine darks, as well as some handsome grays.

Raw umber. This is a darker version of raw sienna, and you can get along without it.

Burnt umber. This color is a must. It's the darkest earth color: it comes out of the tube just a bit lighter than black. I use it a great deal in my darkest areas when I paint a head. It mixes well with blues and greens: burnt umber and any of the blues make a very nice gray.

Black. I don't use black much, but I always have it handy. I don't agree with the idea that one shouldn't use black, but do feel that it can be overused in a dark. It seems that, when students want to make something darker, they automatically think of using black. Unfortunately, black doesn't mix well with many colors and, unless you know what you're doing, I'd suggest you use burnt umber as your basic dark. As you'll see, I usually suggest mixing Phthalo blue with alizarin crimson, burnt sienna, or burnt umber to make the darkest darks. Experiment with black, and observe its characteristics for yourself.

21 Mixing Color

Now that I've suggested a palette of colors, I'll discuss the various mixtures of those colors I'll be using for the following full color portraits. I'll discuss mixing only flesh tones here, because I think that's the area that troubles students most.

Naturally, there's no single way to paint flesh tones: complexions differ from one subject to another. But it's certainly possible to generalize to some extent, so I'll outline some general combinations you can use to paint light and dark complexions. I don't say these are the only mixtures to use—the colors *you* use will be your mark as an artist—but start by using these colors and then experiment with your own mixtures.

I generally use these basic colors for mixing flesh tones: cadmium yellow pale, cadmium yellow light, cadmium yellow lemon, yellow ochre, raw sienna, Hooker's green, sap green, Phthalo blue, and cerulean blue. For the lightest complexions, I use cadmium red light mixed with cadmium yellow pale or cadmium yellow light. I occasionally mix yellow ochre with my cadmium red light for light complexions. Whether you use a cadmium yellow or yellow ochre depends on your own feeling about the complexion. I think the cadmium yellow creates a fresher complexion tone, but yellow ochre is easier to handle.

Just remember that a little bit of any yellow goes a long way when you're mixing it with red: start with a very small amount of yellow, and see what happens. Remember also that the combination on your palette will look different when it's applied to white paper, so be sure to test each new mixture. The first result probably won't be satisfactory and you'll have to continue mixing. It's impossible for me to give you any more specific instructions on mixing: I can't tell you exactly how much red you should mix with exactly how much yellow. Mixing takes a great deal of experience, so just experiment with various ratios of red to yellow. (When you finish adding one color, be sure to rinse your brush before you add another color.)

Now, let's try some of the various combinations you can mix for light and dark complexions.

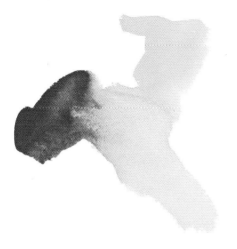

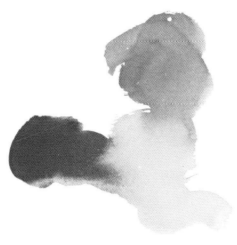

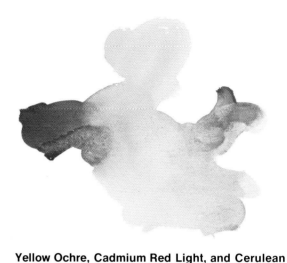

Cadmium Yellow Lemon and Cadmium Red Light. Here, I mix cadmium yellow lemon with cadmium red light. Notice that I place these colors about an inch apart. Then I go back to the water supply, rinse my brush, and, with a damp brush, come back and draw the two colors together to create a fairly light complexion tone. Actually, I've used a bit too much water in this particular swatch and the result is a bit too light.

Yellow Ochre and Cadmium Red Light. In this case, I substitute yellow ochre for the cadmium yellow. The result is very similar to the first swatch, and I'm sure it's impossible to tell the difference between the two *blended* areas. It's quite safe to say that you can use a cadmium yellow or yellow ochre interchangeably.

Yellow Ochre, Cadmium Red Light, and Cerulean Blue. Now I add a third color—cerulean blue—to my combination. It's usually necessary to cut the intensity of the yellow-red combination and, as you'll see in the following demonstrations, many areas of the face are very cool. Notice what happens here when the blue is mixed with the yellow-red combination. We can see the warm color slowly changing and becoming much cooler.

Cadmium Yellow Light, Cadmium Red Light, and Sap Green. Instead of using cerulean blue this time, I substitute sap green. The result is quite different: this combination is much mellower. The green is much better in a complexion that's on the yellow side, while blue is much better in a fair complexion.

Raw Sienna, Cadmium Red Light, and Phthalo Blue. Now we're getting into dark complexions. Here, I use phthalo blue instead of cerulean blue, raw sienna instead of cadmium yellow, and less water to mix these colors together. The result is much darker than the previous swatches.

Raw Sienna, Cadmium Red Light, and Hooker's Green. Finally, I substitute Hooker's green for the phthalo blue. I still use cadmium red and raw sienna for my two warmer colors. We'd use these last two mixtures for dark-complected people and for shadows in light complexions.

22 Girl with Headband

Now I'll combine the principles and techniques of using and mixing color to show you how to paint a full color portrait. My subject will be a girl, mostly in shadow, with the light coming from behind and to the right.

This is a good lighting situation to work with when you're using color. As a rule in this back lighting situation, the shadow areas have many *color* changes but few *value* changes, while the light areas have fewer color and more value changes. Keep this rule in mind. Although you'll find many exceptions to it, I think it's safe to say that shadows in this lighting situation are simple in terms of value, without a jumble of value changes.

Of course, other lighting situations do create exciting color changes in the areas in light. But in this exercise, there aren't many color changes in the light areas, and most of the action—as far as color is concerned—will take place in the shadow areas.

Whenever you paint a color portrait, try to capture the particular complexion of your subject. Remember that colors vary from one face to another: some complexions are very cool and seem quite gray, with very little red or yellow in them, while other complexions are warm and appear very red or very yellow. Generally, I've also found that the middle section of the head—the ears, cheeks, and nose—tend to be warmer than the forehead and the chin.

The procedure I'll use here is the one I generally use in painting color portraits, with minor variations that depend on the lighting situation, the subject, and my desire to experiment. I'll take some time to make my sketch fairly accurate. I'll use a basic oval as my foundation and I'll use ellipses to indicate form and the placement of the features. I'll use the same materials we've used all along, and the palette of colors I suggested in Demonstration 20.

Preliminary Sketch.

Girl: Step 1. I mix my initial wash with three colors: cadmium red light, cadmium yellow pale (you could use yellow ochre), and a touch of cerulean blue (or sap green). The result of adding this third, *cool* color to the wash will be a rather subtle transition between the warm and cool areas on the face. I block in the left side of the nose, the left cheek, and both eye areas.

Girl: Step 2. I extend my first wash to cover the left side of the face and neck, paying attention to the contours of the nose, the upper and lower lips, the chin, and the neck. (Notice that a "balloon" has developed in the neck and that an area of the left cheek is too dark. I'll ignore these bothersome mistakes for now. They'll probably be hardly noticeable on the finished head.) Now I mix a puddle of cerulean blue on my palette, load my brush and shake it, and start washing in shadows wet-in-wet. I work upward from the warm wash, drawing the cooler color to the left temple, across the forehead, and around to the right eye socket. I leave a small finger of light jutting into this shadow, as the beginning of a light rim on the top plane of the nose.

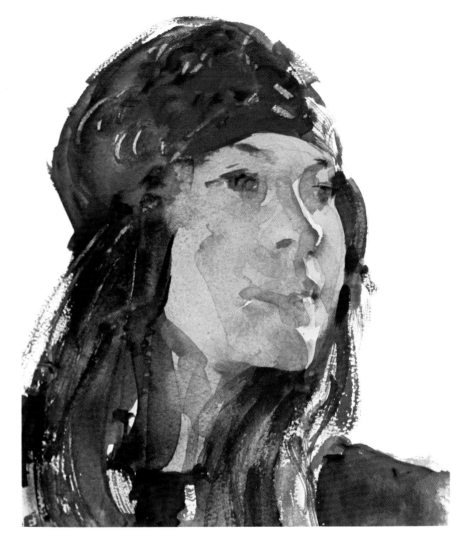

Girl: Step 3. Without pausing, I work the cool wash down into the lower cheeks, the mouth area, the chin, and the neck. Then I mix some cool color into my basic warm wash and block in the shadow on the right side of the face. This area is not as close to us as the left side of the face, so it should be cooler than the closer areas. When the washes on the face are just damp, I start blocking in the hair, using burnt umber and burnt sienna mixed with cerulean blue. Then I use undiluted cadmium red to begin blocking in the headband. (Notice that, even with pure pigment, some of the red has bled into the hair. I'll fix it later.)

Girl: Step 4. I complete the headband, hair, and shirt, occasionally blotting those areas with a tissue to lighten them, to suggest texture, and to soften edges. Now I try to suggest the eyes while I keep them soft and indistinct. I begin with light brown washes and slowly work toward the area where I'll place my darkest dark. For this very dark accent, I use pure burnt umber with a touch of cerulean blue, and I make only a very small dot. I darken the complexion by restating the dark rim along the nose and suggesting shadow on the front plane of the face. Then I add a dark accent at the light corner of the mouth. While the headband is still wet, I scratch out some highlights. When the washes on the face are dry, I darken them to make the planes more definite.

23
Oriental Child

My subject this time is a Japanese boy, under a rather strong side light. The right half of his face is in shadow, while the left half is in the light.

I'll use the same colors here that I've used all along: the only real difference in my procedure will be that I'll use the colors in different *proportions*. My first wash will be darker than one I'd mix for a light complexion, because I'll need a *lower* range of values in the shadow areas. However, the areas of the face that are in the light won't really be much darker than those of a light complexion. To me, the complexion of Oriental people doesn't seem much darker than that of white people: I think the more obvious difference between the two races is in the construction of the *features*.

There are some interesting shapes in this head. For example, the right ear is quite prominent, and I've tried to develop the interesting shape in my preliminary sketch. Notice also the difference between the shapes of the right and left sides of the head. The lower right cheek is definitely angular, while the left side is described by a gentle curve.

The nose, which is rather flat, also needs a lot of attention. Take a look at the sketch below and you'll see what I mean. The "wings" above the nostrils are important and should be carefully delineated. When I paint in the nose, I'll first cover it with a dark overwash to describe the side plane of the tip of the nose on the shadow side. Then, I'll lighten the front plane of the wing on the shadow side and add the darker nostrils to bring the whole nose area into focus. The nostrils shouldn't be as dark as the eyes, or they'll look like two holes in the face, so I'll use burnt sienna and burnt umber for the nostrils—*not* black or Payne's gray.

In my finished painting, I'd like you to notice that there are more value changes in the light areas than in the shadows, which are painted with just one value. The shadows here aren't really more colorful than the light areas, although I've added some rather strong red (probably too strong) under the nose and in the right ear. I think it's a good practice to go a little overboard in some areas and make a good, strong statement of color. Even if you do this in a very small area, it might help you to get out of the habit of using bland color.

When you work wet-in-wet, as I will for this painting, remember to use enough pigment. Even if you use *too much* and strong color contrasts show up, it's all right. The contrasts may look too obvious at first, but they'll probably blend with the rest of the wash as it dries—and color contrasts will add excitement to your paintings! It's much better to use strong color in your first steps than to have a weak, washed-out look.

Preliminary Sketch.

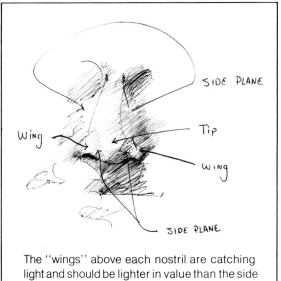

SIDE PLANE

Wing

Tip

Wing

SIDE PLANE

The "wings" above each nostril are catching light and should be lighter in value than the side planes of the tip of the nose.

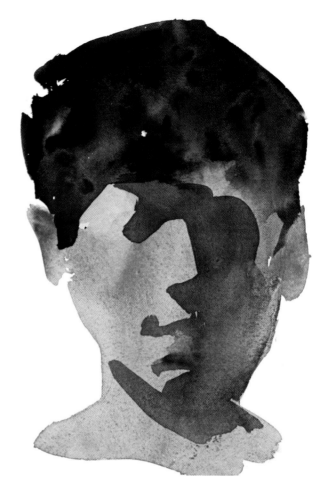

Oriental Child: Step 1. I mix up a rich wash of cadmium red light, raw sienna, a very little bit of cerulean blue, and sap green (I could also have used Hooker's green). I want only a very small amount of cool color in this first wash, since I want it to have an overall feeling of warmth. You can see that red is the dominant color. As I work out toward the boundaries, I add more cerulean blue on the right side of the head, and more sap green on the left. (Again, I could have used Hooker's green.) I work quickly, wet-in-wet, using more pigment as I add cool colors to my puddle. The light is coming from the upper left, so, before my first wash dries, I blot the upper left side of the face lightly with a tissue.

Oriental Child: Step 2. I mass in the hair, using almost pure burnt sienna and Payne's gray, with a little phthalo blue. The face has already dried, and a hard edge is developing as I add the hair. This is fine on the left side, but I want a soft edge in the shadow; so I clean and shake my brush and work it up into the hair to soften and lift out the hard edge. I use almost the same mixture on my shadow shapes, but I substitute Hooker's green for sap green to make an even darker wash. Working down the middle of the head, I wash in my shadows broadly, developing the shapes of the eyes, nose, mouth, and chin. Now I add more cool color—primarily cerulean blue—to my puddle and wash in the right side of the face. Reflected light makes this area a bit lighter than the center of the face, but not as light as the main light areas. While my shadow wash is still very wet, I run a clean, damp brush down the right side plane to soften the division between the shadow and the areas of reflected light.

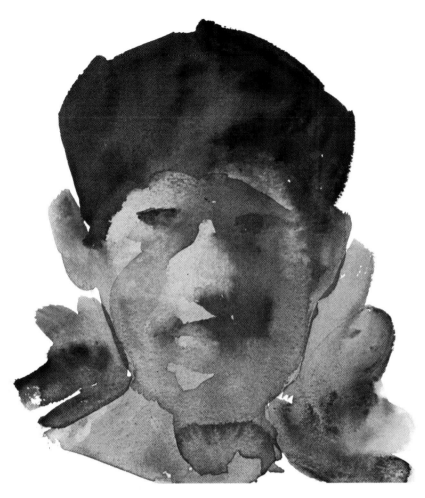
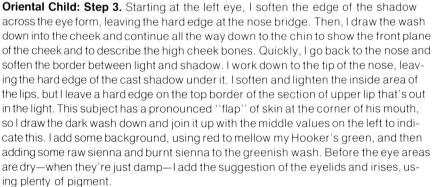

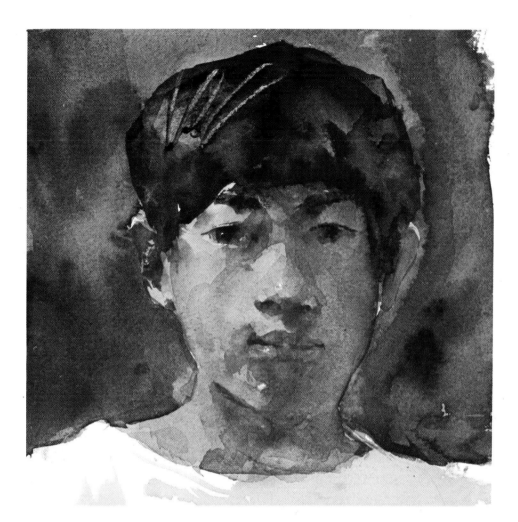

Oriental Child: Step 3. Starting at the left eye, I soften the edge of the shadow across the eye form, leaving the hard edge at the nose bridge. Then, I draw the wash down into the cheek and continue all the way down to the chin to show the front plane of the cheek and to describe the high cheek bones. Quickly, I go back to the nose and soften the border between light and shadow. I work down to the tip of the nose, leaving the hard edge of the cast shadow under it. I soften and lighten the inside area of the lips, but I leave a hard edge on the top border of the section of upper lip that's out in the light. This subject has a pronounced "flap" of skin at the corner of his mouth, so I draw the dark wash down and join it up with the middle values on the left to indicate this. I add some background, using red to mellow my Hooker's green, and then adding some raw sienna and burnt sienna to the greenish wash. Before the eye areas are dry—when they're just damp—I add the suggestion of the eyelids and irises, using plenty of pigment.

Oriental Child: Step 4. Now I try to give more definition to some areas and some features, while I retain the soft, "lost" quality in other areas. (First, I finish the background, to keep the whole picture going at the same pace.) I paint the boy's white T-shirt, which gives the picture a pattern and design by contrasting strongly with the darker values of the head and background. I restate the hair, adding darker values in some areas and scratching out some strands. Next, I work into the eyes with a wet brush, lifting out a light strip where the lower lid is catching some light. I develop the mouth, leaving the darkest area at the left corner and breaking the division between the lips at several places. I work quite hard to define the chin and the darker area below the lower lip, putting in darks and blotting them with a tissue until the values are right. Finally, I add some shadow areas to the T-shirt, using lighter shadows here because the shirt itself is light.

24
Bearded Lobsterman

Preliminary Sketch.

In this demonstration, I'll use transparent washes initially; when they dry, I'll go into drybrush, applying pure pigment over the dried washes.

The first principle I hope you'll keep in mind here is this: *after* you've established your large masses of light and shadow, solved your drawing problems, and developed some good color, you can carry a picture just as far as you wish in terms of texture and detail. To many people, *detail* is the most impressive part of a good representational painting, but this has always seemed wrong to me. Even amateur artists can develop marvelous detail! I think the trick really lies in the preliminary considerations: good drawing, good values and pattern, and good color. When you've solved these basic problems, the sky's the limit on the amount of "finish" you can add. (Remember, of course, that detail must always be developed with the *whole picture* in mind. Detail must never take over and destroy the good pattern and value range you've developed.)

The second point I hope you'll remember is that you must not finish a picture to the same degree in all areas. To make *some detail* work, other areas must be *generalized* and only suggested. Andrew Wyeth is a master at handling highly finished paintings beautifully. If you have an opportunity to see an original by Mr. Wyeth, I think you'll see what I mean. At first, the whole painting will appear detailed, with every blade of grass rendered carefully, but if you really examine the painting, you'll find many generalized "lost" areas, where there is no detail. The finished areas work so beautifully with the lost, generalized areas that we have the impression that the *whole* picture is highly rendered.

My friend Henley, who's a lobsterman on Monhegan Island, Maine, is the subject of this demonstration, and I'm using photographs as reference. I took these pictures of Henley while he was pulling traps on what *I* thought was a very cold day in February. (I'm sure he found it quite mild.) I wish I could say that I did the painting from life, but it was far too cold for me, and there's no room on a lobster boat for painting. I was especially interested in the raking light that's coming from the left. It's hard to fake a specific light like this without a great deal of experience, so this is a case where I think it's perfectly legitimate to use a photograph. Besides, if Winslow Homer worked from photographs, so can I!

The light is coming from the left, behind the subject, and most of the head is in shadow; so I'll start right out with my shadow wash in Step 1. As a rule, I try to go overboard with color when I begin to block in my shadow washes. When I block in my light wash in Step 2, I'll be ready to wipe it out with a tissue if it looks too dark or too strong. Don't be afraid to use a tissue liberally for blotting and wiping out. I use one often in a painting like this. I'm not after a spontaneous, wet watercolor look here, and I won't worry about overworking the painting.

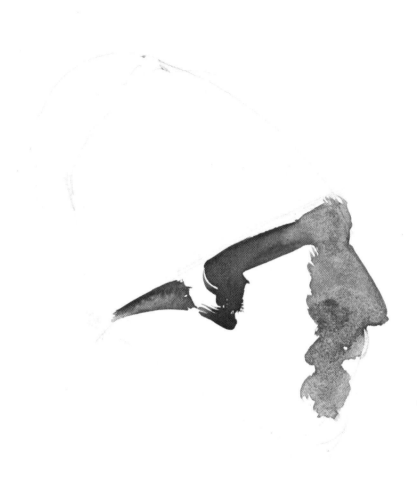

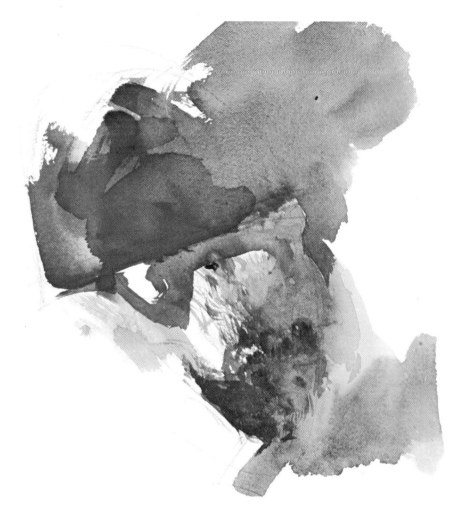

Bearded Lobsterman: Step 1. I use mostly red, with a touch of raw sienna, behind the hair. Skipping the ear itself, I use the same colors until I approach the eye area. Here, I rinse my brush and dip it into cerulean blue mixed with just a bit of water. Since I'm going to use wet-in-wet later, I brush almost pure pigment into the eye area. I add more red and raw sienna to the original shadow puddle on my palette and brush in some warmer color on the cheek. I'm working quickly, to make sure I get good blends. Now, I add more cool color around the mouth area. Since I'm going to restate these shadows, I don't worry too much if the warm-cool contrasts are too great at this point.

Bearded Lobsterman: Step 2. The background at the front of the face is very close in value to many of the shadows on the face. So I paint in the background along this area and allow it to blend with the shadows on the nose and in the beard area. I'm careful to keep a fairly firm edge around the eye, since this area is more obviously separated from the background. I'll wait for the eye area to dry before I put in the background here. I work into the beard, using wet-in-wet. Some of the beard near the jawline is struck by light, so I'm careful to leave most of this area untouched. I use some drybrush in the beard, being careful not to overdo it. I begin to wash in the light-struck area of the skin. This is where a little cadmium orange comes in handy: I add it to my very light wash for a very light area that still needs strength. (You might also try some cadmium yellow.) I start the hat, using cadmium red mixed with a little cadmium orange and burnt sienna. The red alone would be a little too raw.

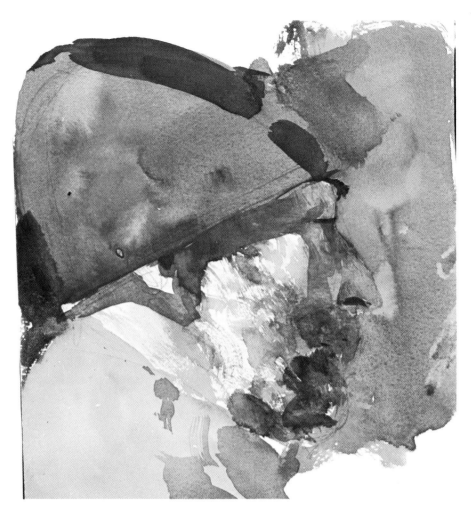

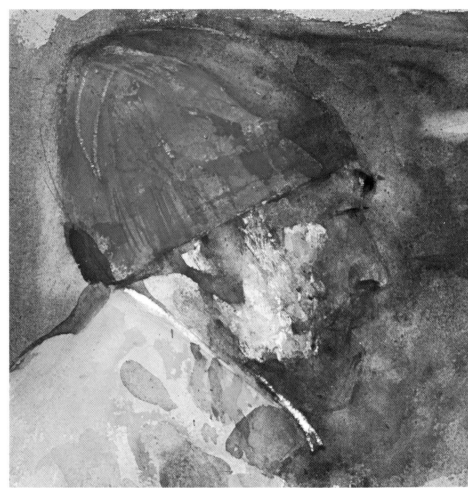

Bearded Lobsterman: Step 3. Now, I begin to bring things together. I allow my washes to dry so I can see where I stand. I add more background and start to define the nose and beard. I darken the beard with wet-in-wet, using cerulean blue, some burnt umber, and burnt sienna. It's hard to be exact here. I add the yellow foul-weather jacket, and I place some of the important shadow shapes on the jacket when the first yellow wash is dry, using cadmium yellow light, mixed with a little orange. (Cadmium yellow medium might also work well here.) For the shadows, I use some raw sienna, some raw umber, and a touch of cerulean blue.

Bearded Lobsterman: Step 4. I add my finishing touches now. As I said earlier, you can carry your final step just as far as you wish (but there is a stage at which—depending upon your abilities—you can reach a peak and start back downhill; so you should be ready to wipe out!) Don't let your picture harden as you approach the end. Keep some big blurs, like the areas I'm leaving in the hat and beard. As you start to scratch out in your final steps, don't indiscriminately pick away with your razor blade. Notice that the light-struck sections of this beard have a particular placement, which gives the beard form. Always be sure that your cast shadows describe the form on which they lie. For example, the cast shadow on the neck describes the round cylinder-like form of the neck. Notice the values in the shadows and in the cast shadows. They're dark enough to show that they're shadows, but light enough to appear luminous and airy.

25
Child in Sunlight

In this demonstration, I'll discuss *sketching* a child with watercolor. The subject is my son Peter. Again, I'll use sunlight to help me create a feeling of the structure of Peter's head. Without strong light and shade to help indicate form, a sketch like this wouldn't be possible.

A picture like this can succeed or fail on several different levels. It doesn't have to be a perfect likeness in the literal sense: I'd consider a sketch successful if it caught even a fleeting impression of the particular subject, whether that were accomplished in the overall shapes and construction or in a particular stance or gesture.

As you can see in the illustration for Step 3, this painting is much broader than the one I did for the previous demonstration. I'm not the least concerned with detail here. Instead, I want to create a feeling of light and atmosphere: I want an *impression* of this boy and the sunlight shining on him. In the last demonstration, we were concerned with a completely different kind of watercolor, and freshness wasn't really as important as the character of the particular subject. I hope you can see the difference between these two approaches.

Don't feel locked into using the colors I use in these demonstrations: experiment with these and other colors on your own. You might find that the colors I've suggested are fine, but I hope you'll try some others, too.

Preliminary Sketch.

Child in Sunlight: Step 1. I wash in the light values, covering the whole face. I want a fresh complexion, so I mix quite a bit of cadmium yellow lemon with my cadmium red. Although I don't often use cadmium orange, I do try it occasionally in a light, fresh complexion such as this, and I'll add a bit of it here. The main light is coming from the right, so I lighten the area around the left eye by blotting it lightly with my tissue. Although I'm putting wet washes next to one another, I'm not too worried about the bleeding that will take place.

Child in Sunlight: Step 2. When my first washes are dry, I start adding some browns to the front section of the hair, using burnt umber. Then I mix up a warm shadow wash of cadmium red light and yellow ochre. I want this wash to be quite dark, so I use very little water. (You could use raw sienna instead of the ochre.) I start blocking in the shadows, and I indicate the cooler, reflected light by adding cerulean blue wet-in-wet to make a good blend.

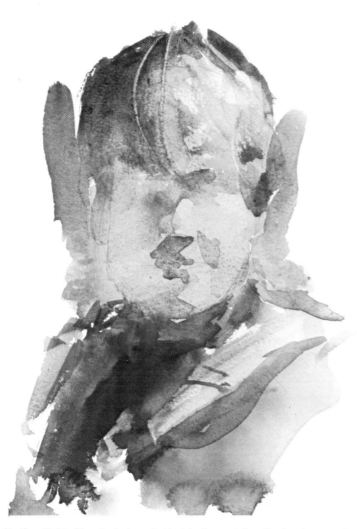

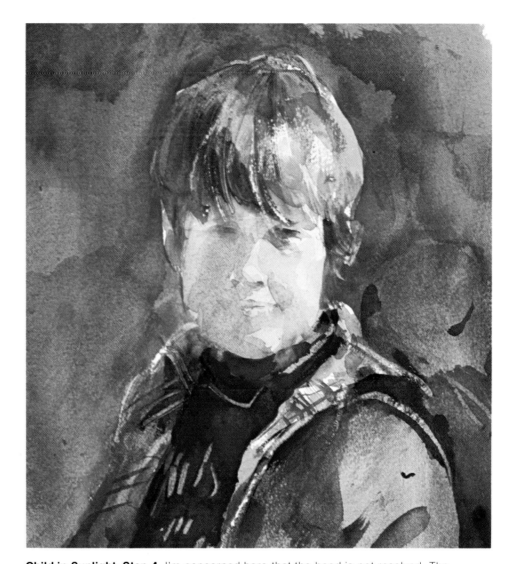

Child in Sunlight: Step 3. As I work, I hold off on adding the background areas adjacent to the light sections of the face until those sections are dry. I want crisp edges on the boundaries that face the light, but the boundaries in the shadow areas should blend and blur. My boundaries on the left side aren't correct, so I wipe them out with a tissue. As areas in the light become dry, I restate edges and forms. These are definite shadows on the left side of the face, so I add a darker wash. I think you can see how fluid my painting is at this stage. This is really why I don't do a more careful preliminary drawing! I like the feeling that I'm not bound by exact outlines. This is *my* way of working, however, and you might well prefer to work with more careful guidelines.

Child in Sunlight: Step 4. I'm concerned here that the head is not resolved. The shadows really need to be darker and more definite—but I've destroyed so many pictures by adding another shadow wash! I might gain more definition if I add one here, but I also might lose the freshness that's so important. Although some watercolor paintings can be corrected and reworked without being damaged—in fact, corrections and reworkings might occasionally be assets—some paintings demand that ''*premier coup*'' look that you can only get with just one or two *fresh* transparent washes. In this sketch, I've managed to leave the head alone, but I've overworked the jacket. Can you see that the jacket looks ''tired'' in comparison to the face?

26 Full Figure

Preliminary Sketch.

For this final demonstration, I had planned to do a very finished, involved figure, but I must admit that finished, involved figures aren't really my style. And there's actually no point in doing something very involved for a demonstration, because finishing touches would make up most of the work, and these are extremely difficult to demonstrate. So this final painting will be like most of the paintings in this book: in a sense "unfinished." But I hope that by seeing paintings in this state, you'll observe and learn more of what goes into painting portraits.

This will be a painting of my wife Judy, sitting in strong sunlight. I've always had a great deal of trouble painting members of my family, because I've always tried to get a particularly good likeness. I think the more a painter worries about likenesses, the harder they are to come by. When I'm painting a model or one of my friends, I relax and don't worry about a likeness, and the likeness seems to happen anyway! So I can certainly say that you should never worry about likeness—just concentrate on doing a good painting!

In this case, however, the final painting does look like Judy. Notice in Step 4 that I've tried to create a feeling of strong sunlight and that I've concentrated on the *form* of the head, rather than on the specific details. I think a good likeness depends more upon the development of the overall form of a particular head than on the small details. In the final painting, there aren't really any details in the face, but the painting looks like the subject because the *structure* has been carefully observed and blocked in. (Of course, it's much easier to describe structure when the subject is under a strong light source. It's much harder to make these broad decisions when the light is very subtle or when several sources of light confuse the simple planes.)

In my preliminary drawing, as in all of my drawings, I'll concentrate on gesture, rather than on the specific features, and try to describe the particular way this model is sitting. I'll try to place the features accurately—to correctly indicate the relative distances from the forehead to the eyes, the eyes to the nose, and the nose to the chin, etc.—but, more important, I'll try to describe the relative sizes and shapes of the features and the head as a whole, without pinning down the specific details of a particular area.

I think some areas of the final painting are overworked. But I want you to see that mistakes don't really ruin a painting, and some of the blurs and poor areas actually create a feeling of *involvement* that a beautifully done, flawless watercolor might lack. Edgar Degas said that a painting looks like a battle—but a battle that the artist has won!

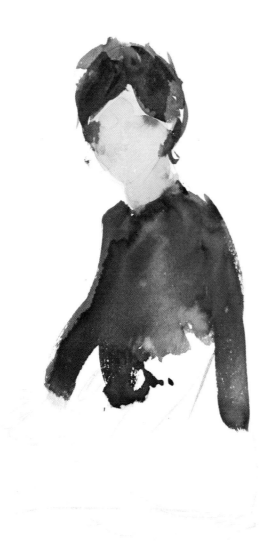

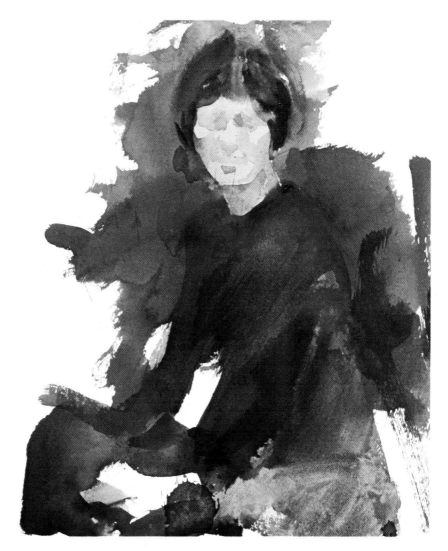

Full Figure: Step 1. At this stage, I'll mass in the basic colors and establish the colors that will dominate the painting. I begin with the face, which is quite light because it's in strong sunlight. Then I wash in the hair with burnt sienna and cerulean blue, using a great deal of pigment. (The face wash wasn't quite dry, and some of the hair color ran into it. I'll blot this with a tissue.) While the neck is still damp, I wash in the sweater with phthalo blue, alizarin crimson, and burnt sienna, allowing the colors to blend on the paper. It doesn't really matter which colors I use here, as long as they're *dark*.

Full Figure: Step 2. The sweater is still wet as I add the background, and you can see that the two areas blend together. (This is a very good idea when you place two very similar values next to each other. Just use plenty of pigment and keep shaking the excess moisture out of your brush to keep such areas rich and dark.) I use a tissue to wipe out and soften some areas, including the light-struck lower right portion of the figure. Notice the number of soft edges at this stage; the painting is very fluid and loose.

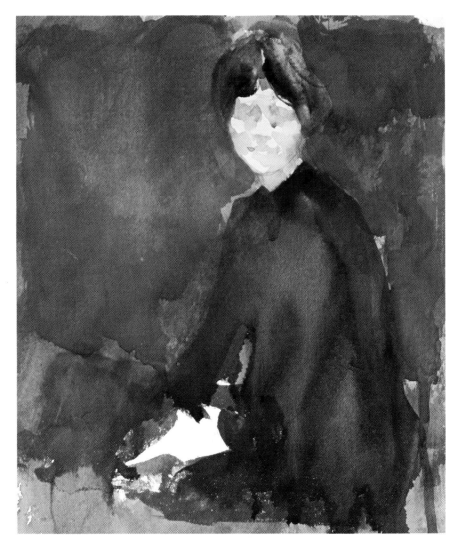

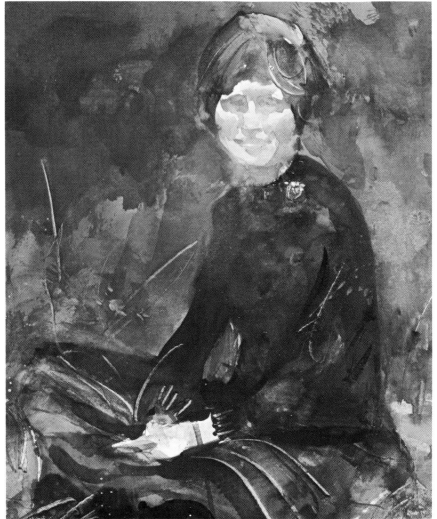

Full Figure: Step 3. I complete the background, keeping a great deal of softness throughout the picture. I leave the area of the hands untouched for now, along with an area on the ground, because these will be the lightest areas of the picture. (I used a bit too much water in my clothing mixtures, and the sweater has become too light. I'll restate it at a later stage.) I carefully articulate the more definite shadow shapes in the face, trying to indicate the major planes of light and shadows and not worrying about the details.

Full Figure: Step 4. I bring the face into focus, adding a minimum of detail around the eyes and mouth, and allowing the eyes to play a secondary role to the lights and shadows. I add some light wash to the hands and restate the clothing, leaving it slightly higher in key than I would normally make it to indicate that the figure is bathed in light. I scratch out some details on the clothing with my fingernail and a brush handle and use a tissue to wipe out some highlights on the light-struck sections of the knees and upper legs. I restate the grass using greens, mixed with blue and raw sienna, scratch out some texture with my fingernail and a brush handle, and add more texture by spattering.

Bibliography

Blake, Wendon, *Acrylic Watercolor.* New York: Watson-Guptill, 1970.

Barcsay, Jeno, *Drapery and the Human Form.* Budapest, Hungary: Corvina Publishers, 1958.

Bridgman, George B., *The Seven Laws of Folds.* New York: Bridgman Publishers, 1942.

Foster, Joseph K., *Raphael Soyer: Drawings & Watercolors.* New York: Crown.

Hogarth, Paul, *Creative Pencil Drawing.* New York: Watson-Guptill, 1964.

Hogarth, Paul, *Drawing People.* New York: Watson-Guptill, 1970.

Hoopes, Donelson F., *Eakins Watercolors.* New York: Watson-Guptill, 1971.

Hoopes, Donelson F., *The American Impressionists.* New York: Watson-Guptill, 1972.

Hoopes, Donelson F., *Winslow Homer Watercolor.* New York: Watson-Guptill, 1969. London: Barrie & Jenkins, 1969.

Kaupelis, Robert, *Learning to Draw.* New York: Watson-Guptill, 1969.

Kent, Norman, *100 Watercolor Techniques.* ed. by Susan E. Meyer, New York: Watson-Guptill, 1966.

McCord, David, *Andrew Wyeth.* (Pub. by Boston Arts Museum) NYGS, 1970.

Mongan, Agnes, *Andrew Wyeth: Dry Brush & Pencil Drawings.* New York: NYGS, 1966.

Moses Soyer. Intro. by Alfred Werner. Cranbury, New Jersey: A. S. Barnes, 1970.

Pellew, John C., *Painting in Watercolor.* New York: Watson-Guptill, 1970.

Werner, Alfred, *Degas Pastels.* New York: Watson-Guptill, 1969. London: Barrie & Jenkins, 1969.

Index

Edited by Lois Miller
Designed by James Craig and Robert Fillie